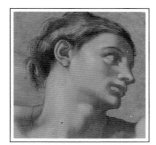

THE LIFE AND WORKS OF

MICHELANGELO

Nathaniel Harris

A Compilation of Works from the

BRIDGEMAN ART LIBRARY

This is a Parragon Book
This edition published in 2002

Parragon, Queen Street House, 4 Queen Street, Bath BA1 1HE, UK

ISBN 0-75251-194-7

Printed in China

Editor:	Barbara Horn, Alexa Stace, Alison Stace, Tucker Slingsby Ltd and Jennifer Warner
Designer:	Robert Mathias, Petro Prá-Lopez, Kingfisher Design Services
Typesetting/DTP:	Frances Prá-Lopez, Kingfisher Design Services
Picture Research:	Kathy Lockley

The publishers would like to thank Joanna Hartley at the Bridgeman Art Library
for her invaluable help.

Michelangelo Buonarroti 1475-1564

Michelangelo Buonarroti was born on 6 March 1475 at Caprese, a Tuscan village where his father was serving as a magistrate of the Florentine republic. Florence was the most important centre of the great cultural movement known as the Renaissance, and so, when his family returned to the city, Michelangelo grew up in absolutely the right place and at absolutely the right time.

At thirteen Michelangelo was apprenticed to Domenico Ghirlandaio, the leading fresco (wall) painter in Florence. But sculpture soon took first place in his ambitions, although we know very little about how he acquired the necessary skills. They were soon apparent enough to attract the notice of the most powerful man in Florence, Lorenzo de' Medici, in whose household Michelangelo studied the ancient Greek and Roman works which Renaissance artists regarded as the ultimate criterion of beauty. Michelangelo's greatest single contribution to art, the heroic male nude, capable of expressing every nuance of emotion, was based directly on the study of classical antiquity and on his burning desire to surpass its greatest achievements.

The 1490s were troubled times for Florence, and so the young Michelangelo looked for commissions elsewhere. In 1496 he came to Rome, where generous patronage enabled him to create his first masterpiece, the wonderful *Pietà* in St Peter's. The solemn beauty of the Virgin mourning the dead Christ displayed one side of his genius; the other was revealed a few years later by the colossal figure of *David*, a glorious, godlike warrior-youth,

symbolizing the spirit of republican Florence, which was triumphantly installed in front of the seat of government.

Not yet thirty, Michelangelo had already reached such a pinnacle of fame that the Florentine authorities determined to match him against the great master of the previous generation, Leonardo da Vinci (1452-1519). The two men were set to paint battle scenes on opposite walls of a council chamber; but the experiment was not a success. Neither artist finished the designated work, although Michelangelo's cartoon (preliminary drawing) of *The Battle of Cascina* was a masterly study of the nude in action, eventually cut up into sections and passed from hand to hand until it disintegrated.

In 1505 Pope Julius II summoned Michelangelo to Rome, which was to become the main centre of the Renaissance thanks to a series of papal schemes of astonishing scope and splendour. Michelangelo's first commission for Julius was a magnificent tomb, but by the time he had assembled the required quantities of marble, the Pope had become involved in an even more ambitious scheme to rebuild St Peter's, and had no time or money to spare for the furious sculptor.

Michelangelo's subsequent flight to Florence was part-indignation and part-paranoia, for he easily became convinced that his rivals were laying deep and dangerous plots against him. Eventually he was more or less compelled to submit to the Pope, and their renewed relationship resulted in Michelangelo's painting of the Sistine Chapel ceiling. This vast, infinitely varied decorative scheme took Michelangelo four years to complete, working in often unnatural and exhausting positions on scaffolding 20 metres (65.6 feet) above the ground. But when revealed in October 1512, the final result overawed the spectators and established its creator as 'the divine Michelangelo'.

Over the next few years Michelangelo struggled to finish Julius' tomb (the Pope died in 1513, but his heirs were clamorous) while

satisfying the demands of the Medici for sculptural and architectural works. The Medici had reestablished their dominant position in Florence, but in 1527 the Florentines expelled them again. In his one venture into politics, Michelangelo supported the new republic and directed the fortification of the city against the next Medici onslaught. Florence nevertheless fell in 1530, and Michelangelo feared for his life; but he was too valuable to kill and was simply set to work again.

Life in Medicean Florence was evidently uncongenial, for in 1534 Michelangelo left the city for Rome, where he spent the rest of his life. His later work is marked by a religious intensity which also appears in his dense, powerfully wrought poetry. As sculptor and painter, and finally as chief architect of St Peter's, he served the Popes right down to his death on 18 February 1564.

▷ **The Madonna of the Steps**
c1491

Marble

IN THIS, probably the earliest of his sculptures, Michelangelo tackles a subject to which he would return several times: the Virgin Mary and the Christ Child, with the mother already touched by a foreboding that her son is destined to suffer and die for others. Although a little uncertain in places, the work is a remarkable feat for a youth of 15 or 16. At the time, Michelangelo had only served a brief apprenticeship with the fresco painter Ghirlandaio, and may possibly have just begun to study the classical statuary owned by the ruler of Florence, Lorenzo de' Medici. *The Madonna of the Steps* is a small work, carved in very low relief, with a fluent treatment of the Madonna's voluminous robe. The steps may symbolize the link between heaven and the holy mother and child.

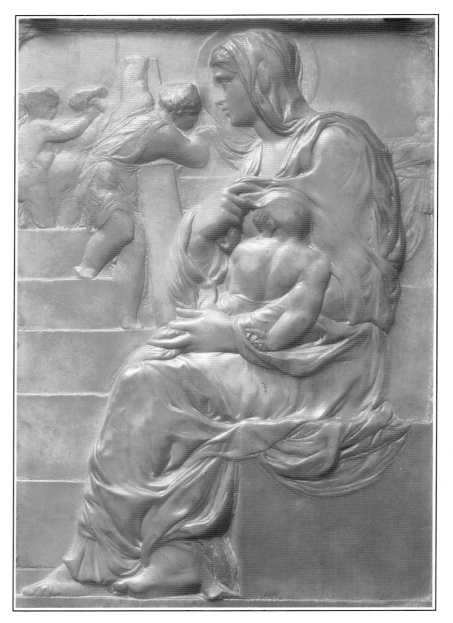

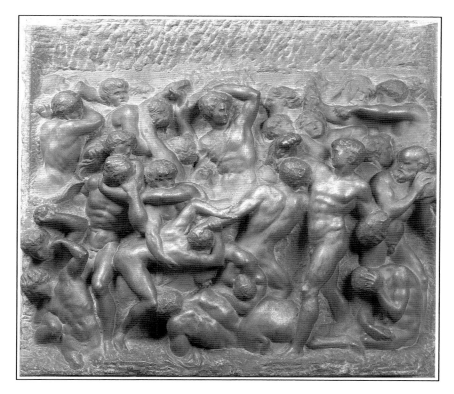

△ **The Battle of the Centaurs** 1492

Marble

ACCORDING TO ONE OF Michelangelo's early biographers, this work was completed shortly before the death of his patron, Lorenzo de' Medici, which occurred on 8 April 1492. By contrast with *The Madonna of the Steps* (page 8), it is carved in a high relief that emphasizes the physicality of the scene. The influence of the Roman statuary which Michelangelo studied in Lorenzo's garden is apparent in the ideal beauty and naked splendour of the figures; Michelangelo shows them in a great variety of postures, in violent interaction, with an astonishingly mature mastery. The subject was taken from classical mythology: the Centaur was a half-human creature, with a head and torso set on the body of a horse. However, Michelangelo arranged the group so that it looks like a battle involving only human antagonists. Here, at the outset of his career, he has found his principal vehicle of artistic expression – the human body.

▷ **Bacchus** c1497

Marble

DURING THE 1490s, the disturbed situation in his native Florence prompted Michelangelo to spend time working in Venice and Bologna before paying his first visit to Rome in June 1496. During a short stay in Florence the previous winter, he had carved a *Sleeping Cupid* in the ancient Roman style, and an unscrupulous dealer had passed it off as a genuine antique. When the furious buyer, Cardinal Riario, discovered the fraud, he demanded his money back; but he also recognized Michelangelo's talent and brought him to Rome. The *Bacchus* was made for Riario's neighbour, the banker Jacopo Galli, in the same classical vein; it was placed among the genuine Roman objects in Galli's garden – minus one arm to make it look convincingly ancient. Life-sized, *Bacchus* was Michelangelo's first masterpiece, with a strong physical presence of a kind rarely seen in sculpture since Roman times.

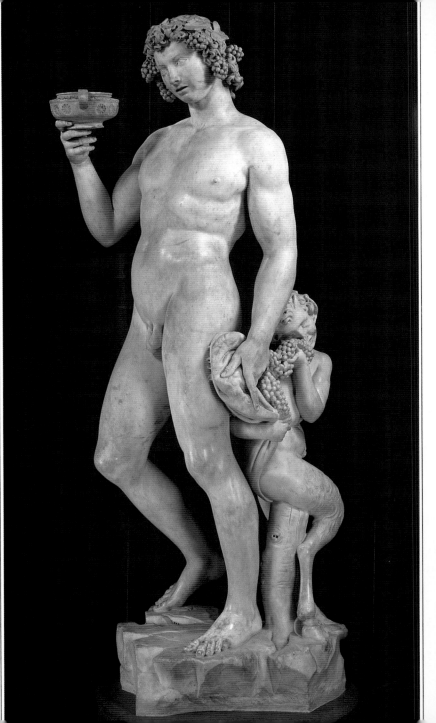

▷ **Pietà** 1498-1500

Marble

A *PIETÀ* IS A REPRESENTATION of the crucified Christ, laid out in the lap of his sorrowing mother. During the 15th century the subject was common in France and Germany but little-known in Italy; and Michelangelo's great sculpture was in fact commissioned by a French cardinal-diplomat, Jean Bilhères de Lagraulas, for his tomb in old St Peter's, Rome. Michelangelo almost certainly intended the work to make him famous (which it did), carving the drapery in elaborate detail and giving the surfaces a high polish such as he never felt to be necessary in later works. The problem of making the group look realistic was triumphantly solved by imperceptible feats of illusion: the Virgin's lap is impossibly wide and voluminous, and if she stood up she would be well over 2 metres (6.6 feet) tall. Michelangelo's Mary is as young as her son. In the manner of the High Renaissance, both figures are physically beautiful, and the atmosphere is one of nobility and restrained emotion. It is still one of the most breathtaking sights in St Peter's.

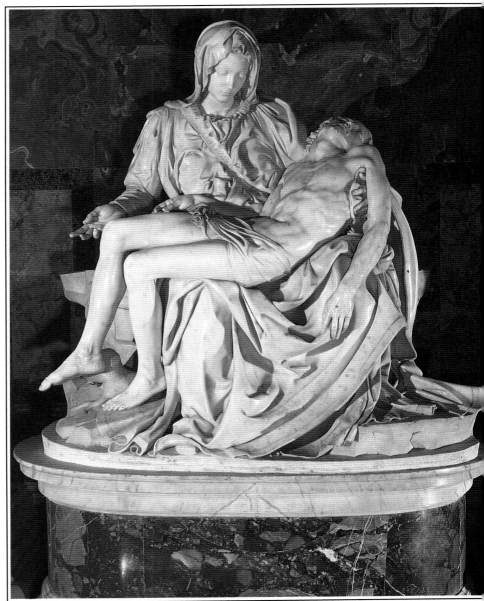

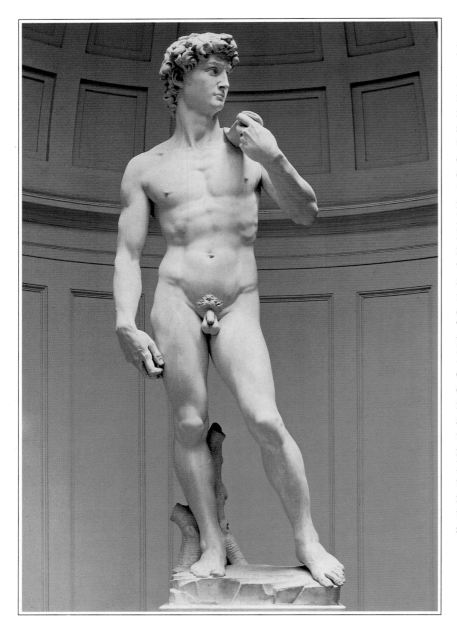

◁ **David** 1504

Marble

IN MAY 1501 MICHELANGELO returned to Florence, where a new republican constitution had stabilized the political situation. One of the ways in which the city celebrated was by financing works of civic art. The greatest prize was 'the Giant', a 5.5 metres (18.1 feet)-high block of marble. Botched by an earlier sculptor, it had lain in the yards of Florence for almost 40 years. Michelangelo won the commission to work on it and, despite the awkward shape of the block, carved the powerful yet entirely natural-seeming *David*. This colossus represents the biblical boy hero who slew the Philistine champion Goliath. In creating a figure that expressed not only heroism but ideal beauty and inner tension, Michelangelo was acknowledged to have surpassed the ancient Greek and Roman models so admired by the Renaissance. In September 1504 the statue was brought into the main city square and installed in the place of honour in front of the seat of government.

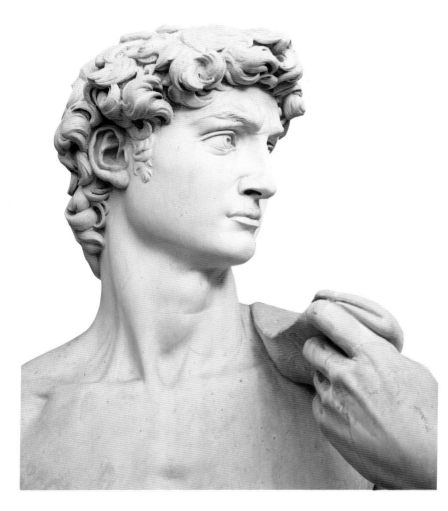

◁ **Head of David** 1504

Marble

THE FLORENTINES HAD long regarded the biblical David as a fit symbol for their own small but 'giant-killing' city-state, which had successfully defied popes and emperors to maintain its independence. Celebrated Florentine sculptors before Michelangelo's time had created David figures, showing him in his moment of triumph, with the head of Goliath as his prize. Michelangelo's version is arguably a more appropriate model for a republic that could never know complete security – a resolute, vigilant young man with his sling over one shoulder, apparently relaxed yet poised for action. For all the classical beauty of his features, Michelangelo's *David* does not belong with the untroubled heroes of antiquity: his furrowed brow places him in a later age of moral and mental perplexities.

Detail

▷ **The Holy Family** c1503

Panel

ALSO KNOWN AS the Doni Tondo. A *tondo* is a circular painting or sculpture; this one is linked with Michelangelo's merchant friend Angelo Doni, who was a perceptive patron and art collector. It was probably painted to celebrate Doni's wedding to Maddalena Strozzi in late 1503 or early 1504; an elaborate frame round the picture carries the arms of the Strozzi family. *The Holy Family* is very much a sculptor's painting, dominated by a compact, stone-solid central group, executed in hard, bright colours and seemingly polished by the light falling on to it. The Virgin is shown in a turning movement characteristic of Michelangelo's style, reaching behind her to take the Christ Child from Joseph. A parapet separates the Holy Family from the figures in the background, most of whom are naked youths apparently absorbed in their own concerns: one interpretation is that they represent the old pagan ways. Only the infant St John the Baptist understands the significance of it all, and gazes adoringly across the barrier.

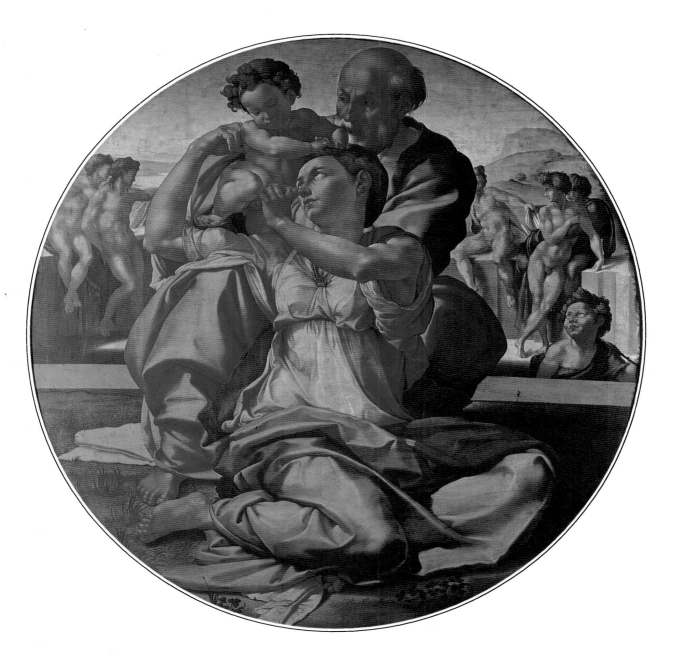

Detail

▷ **Madonna and Child with the Infant St John** c1504-05

Marble

LIKE THE PAINTED *Holy Family* (page 14), this marble relief is a tondo, or circular work of art, a shape popular for wall plaques in domestic interiors of the period. *The Madonna and Child* is often called the Taddei Tondo, since it was made for the collector Taddeo Taddei. It is unfinished, and the visible patterns of Michelangelo's chisel marks give it a special fascination. However, Renaissance connoisseurs were normally impressed only by highly finished works, so it is a sign of Michelangelo's special position that, even at this stage of his career, Taddei and others like him were delighted to have anything from the master's hand. St John the Baptist is holding out a bird to the infant Jesus, who is alarmed and shrinks back against his mother in an unusual and not entirely convincing pose. This pleasant, natural scene conceals a more painful symbolism, the bird unquestionably signifying the suffering and death that Jesus must undergo.

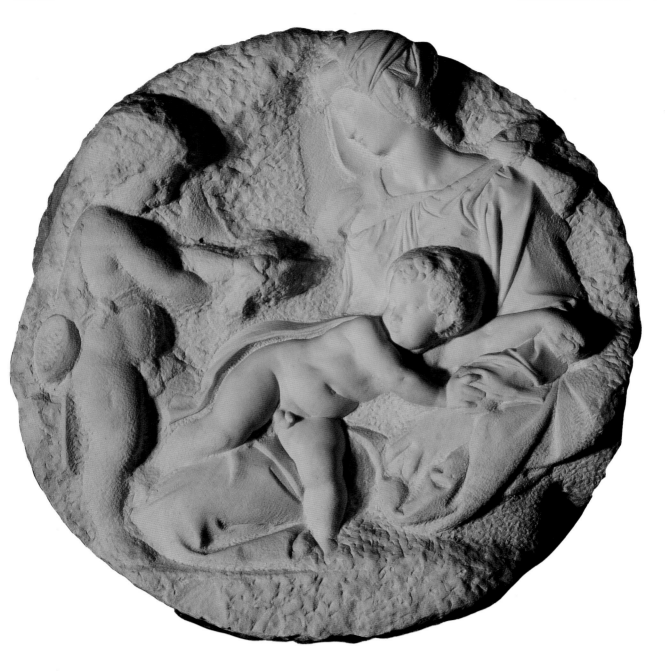

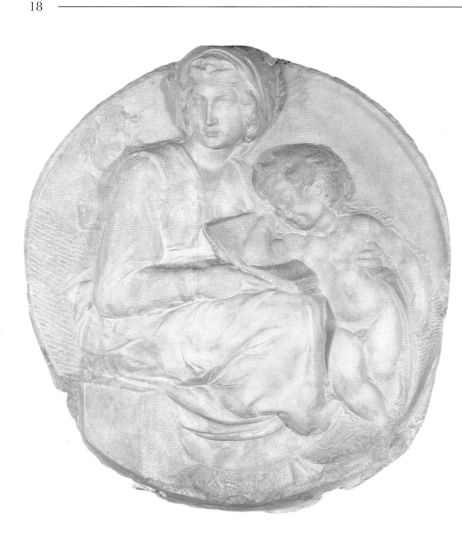

◁ **Madonna and Child**
c1504-05

Marble

THE THIRD OF the *tondi*, or round works of art, created by Michelangelo (see pages 14 -17). Why he should have done so many during the brief period 1503-05, is unexplained. This one is known as the Pitti Tondo, since it was carved for a patron named Bartolommeo Pitti. It is smaller than the Taddei Tondo and, although it is likewise unfinished, has reached a more advanced state and seems an altogether bolder work. The head of the Virgin is carved in very high relief and projects in a remarkable fashion beyond the edge of the disc, as if Michelangelo had tired of the constraints imposed by the *tondo* form, which has severely compressed Mary's seated body. She is also less introspective than most of Michelangelo's Madonnas, gazing alertly past us while her child leans on the open book.

▷ **St Matthew** c1506

Marble

IN APRIL 1503, while he was still
working on his colossal statue of
David (page 12), Michelangelo
signed a contract to carve 12
statues of Apostles for Florence
Cathedral. As so often happened,
he was distracted by other
commissions, culminating in
March 1505 with Pope Julius II's
imperious summons to Rome.
Even so, Michelangelo seems to
have done some work on the
figure of St Matthew, probably in
1506. It was the only one of the
Apostles that he began, and it is
far from complete. But it is also
the first of Michelangelo's
unfinished works which is, to
modern taste, at least as thrilling
as comparable sculptures in which
there is no remaining trace of the
artist's hand. Here, as in the later
'slaves' (pages 48-52), the figure
seems to be trapped in the stone,
from which it struggles
desperately to free itself.

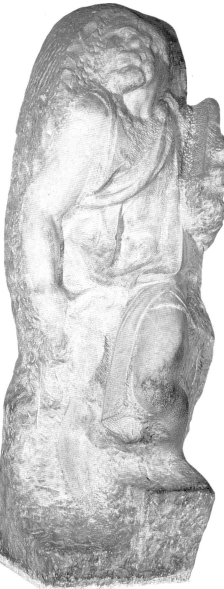

Sistine Chapel 1508-12

Fresco

▷ *Overleaf pages 20-21*

IN MARCH 1505 Michelangelo
was summoned to Rome by the
warrior-Pope Julius II. After a
fraught period during which plans
for the Pope's tomb (page 46)
went awry and Michelangelo fled
back to Florence, Julius persuaded
the artist to return and paint some
figures on the ceiling of the Sistine
Chapel, which stands next to the
Vatican. Michelangelo
complained that he was a sculptor,
not a painter, but he was soon
persuading Julius to expand the
original concept into a vast
decorative scheme covering some
520 square metres (5597.2 square
feet). Typically, Michelangelo
dispensed with the team of
assistants that other masters
employed on such large projects,
labouring almost single-handed
for over 4 years. Urged on by the
impatient Pope, he finally revealed
his work to an assembly of
dignitaries on 31 October 1512.
Its impact was overwhelming. The
Sistine ceiling was recognized as
the mightiest work by a single
individual in the history of
Western art, and his
contemporaries began to call its
creator 'the divine Michelangelo'.

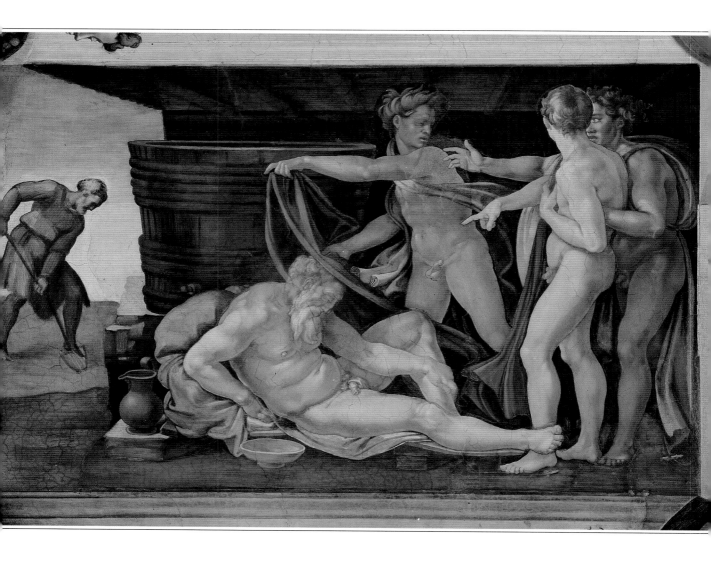

Detail

◁ **The Drunkenness of Noah** Sistine Chapel 1508-12

Fresco

NINE PANELS SHOWING scenes from the Old Testament run down the centre of the Sistine Chapel ceiling. They are arranged in 3 sets of 3, representing the creation of the cosmos; the creation and fall of Adam and Eve, and the story of Noah. Michelangelo actually began with the story of Noah, working backwards in Biblical time, and as *The Drunkenness of Noah* stands over the entrance to the chapel, this was also the order in which the panels were intended to be seen by the worshipper.

Symbolism was evidently more important than chronology, so the sequence begins with human failures and culminates over the altar with the miracles of creation. According to the Old Testament, Noah was the first planter of vineyards, and Michelangelo's painting refers to the occasion on which he became drunk and lay naked in his tent; his son Ham saw his father's condition, and told the other sons, Shem and Japhet, who dutifully looked away while covering him up.

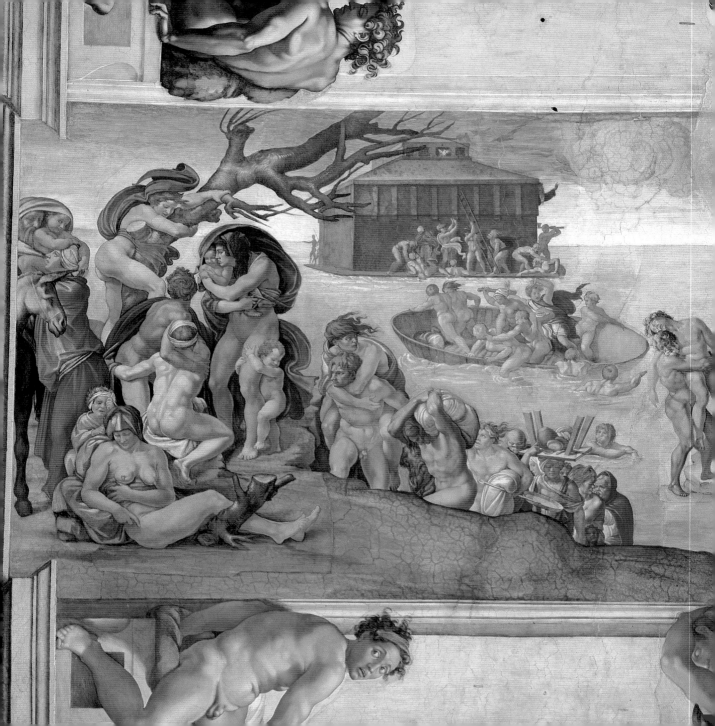

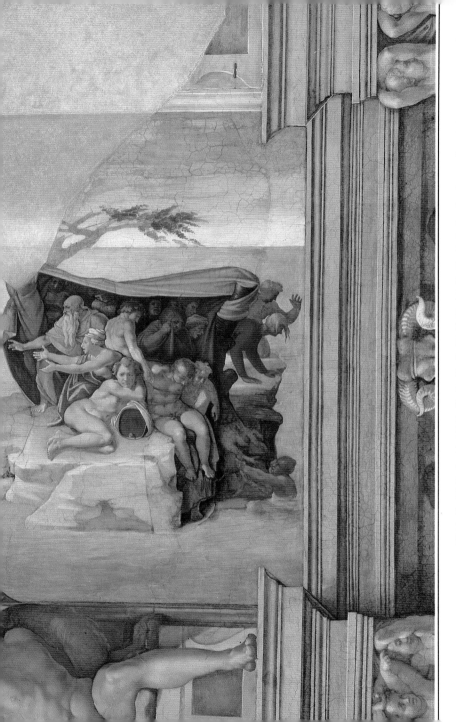

◁ **The Flood** Sistine Chapel
1508-12

Fresco

THERE IS SOME EVIDENCE that
The Flood, which comes second in
the sequence of Biblical episodes
on the Sistine ceiling (after *The
Drunkenness of Noah*, page 23), was
actually the first to be painted.
One significant pointer is that the
scene is too crowded and the
figures too small to be seen clearly
from the ground, some 20 metres
(65.6 feet) below. Michelangelo
must have realized this, for the
figures in the panels on either side
of *The Flood* are somewhat larger
and, as he worked on, his
compositions became even bigger
and bolder. Apart from the matter
of visibility at a distance, *The Flood*
is a masterly work, its harrowing
nature surpassed only by the later
Last Judgement (page 62). Our
response to the scene is sharpened
by our knowledge that the figures
are all doomed; only the single
righteous man, Noah, and his
family, safe in the Ark, will survive.

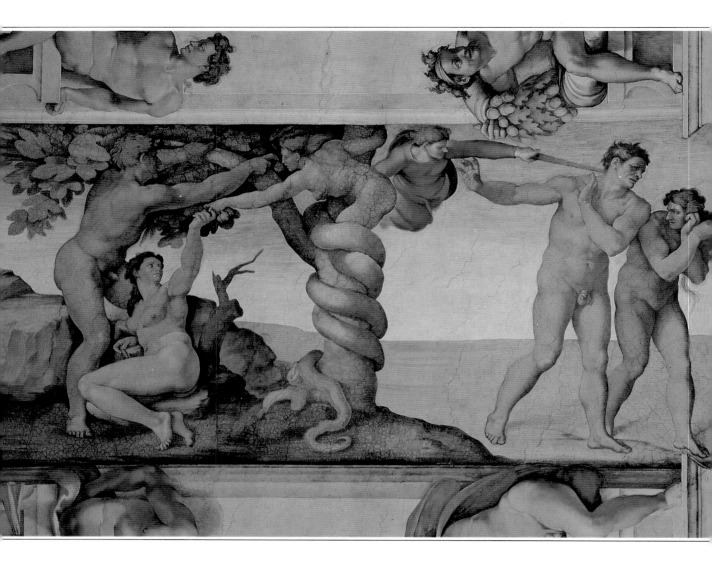

Detail

◁ **The Fall** Sistine Chapel 1508-12

Fresco

AFTER COMPLETING the 3 episodes based on the life of Noah, Michelangelo treated the next triad (*The Fall, The Creation of Eve* and *The Creation of Adam*) with a new freedom and simplicity, enlarging the forms and eliminating background detail. *The Fall* is divided into two scenes by the Tree of the Knowledge of Good and Evil, around which the serpent-tempter is wound. Compounding the mysogyny of the Bible story in which Eve is the first to fall, Michelangelo has made the serpent a near-human female. On the left, Adam and Eve succumb to temptation and accept the fruit; on the right, they are punished by being expelled from the Garden of Eden by an angel armed with a sword. The consequences of the Fall are expressed in direct physical terms: the strong, handsome specimens reaching for the fruit are transformed into huddled, careworn creatures with the signs of mortality already stamped upon them.

The Creation of Adam
Sistine Chapel 1508-12

Fresco

▷ *Overleaf pages 28-29*

This is probably the best known of Michelangelo's mighty images, if only because it has been so relentlessly exploited by advertisers and cartoonists. A nobly beautiful but languid figure, Adam waits to receive a charge of life-energy from his creator. God, swathed in draperies and borne up by a band of youthful angels, stretches out his right arm; the left is thrown protectively round the uncreated Eve, who as yet exists only in the divinity's foreknowledge of events. The thrilling quality of the composition derives in part from the contrast between the lone figure of Adam, lying in a bare landscape, and the purposeful, tightly-packed group swooping down on him. The entire human story is implied in this moment, just before it begins.

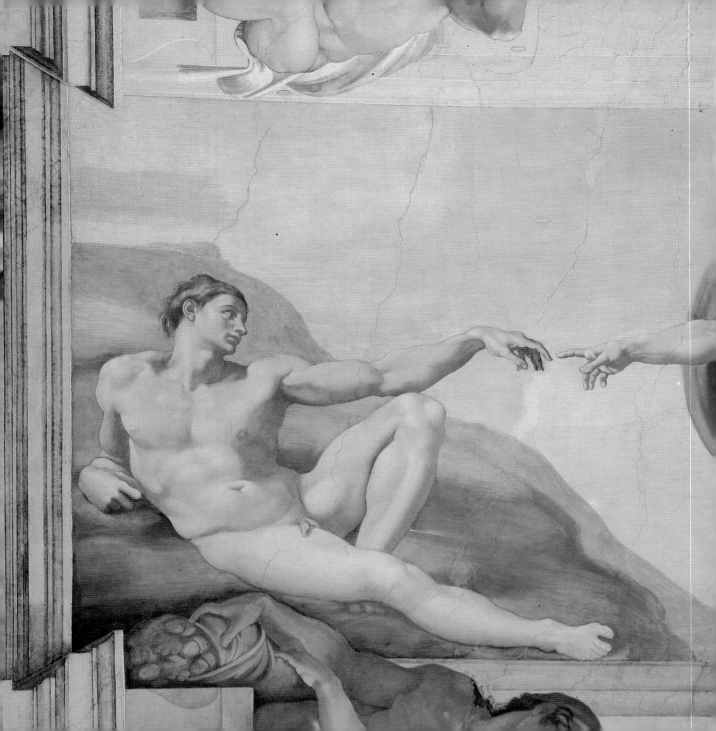

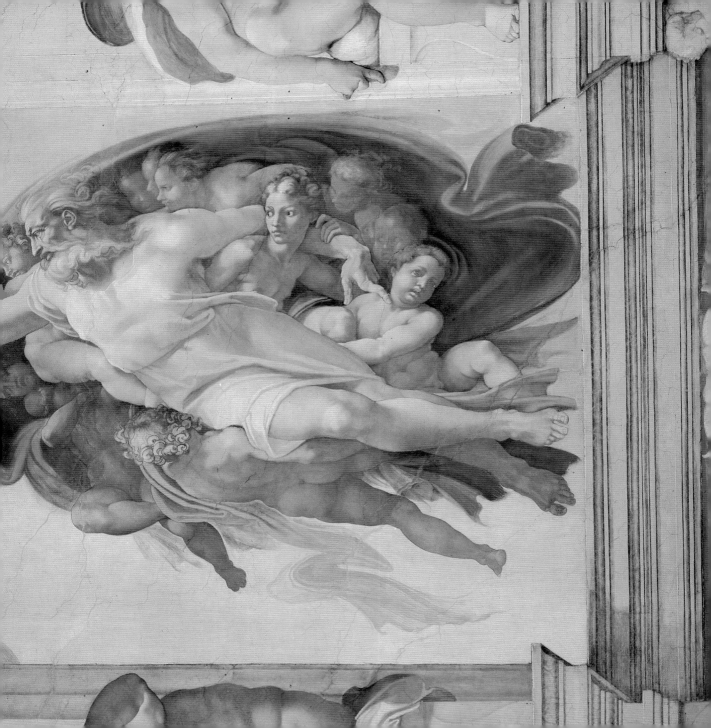

▷ The Creation of the Sun and Moon
Sistine Chapel 1508-12

Fresco

MICHELANGELO'S OLD
TESTAMENT scenes on the Sistine
Chapel ceiling culminate at the
altar end in 3 awe-inspiring
episodes of divine energy: *God
separating Earth from Water, God
separating Light from Darkness* and,
between them, the large picture
which is reproduced here. In the
Bible, human beings are said to
have been created in God's image,
and Michelangelo follows
tradition in making the Deity a
venerable male figure, aged and
grey but instinct with power and
purpose; here he is shown in the
very act of creation, hurling the
sun into its predetermined
position and then wheeling away
to the left. This and the other
ceiling scenes from the Old
Testament serve to complement
the frescoes by other artists on the
walls below, representing the lives
of Moses and of Christ. The
chapel's pictorial account of
revelation was complete, but 20
years later Michelangelo would be
summoned again to the chapel to
paint the end of the entire story:
the *Last Judgement* (page 62).

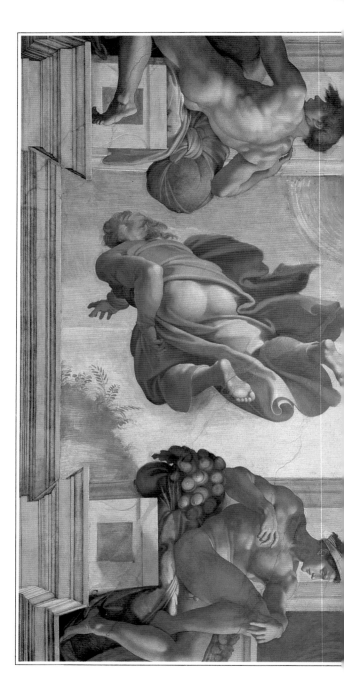

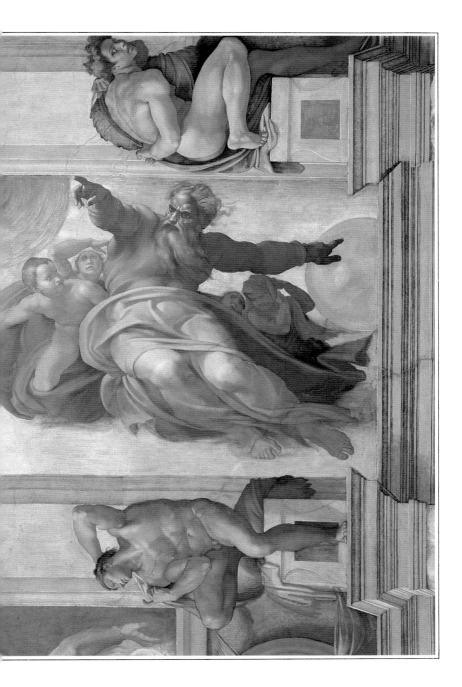

▷ **The Delphic Sibyl**
Sistine Chapel 1508-12

Fresco

THE OLD TESTAMENT SCENES
along the centre of the ceiling are
only part of a larger decorative
scheme by Michelangelo. Among
the most imposing figures are the
prophets and sibyls enthroned in
niches on either side of the central
panels. The sibyls are real or
mythical women of antiquity
whose words were inspired by the
gods. Medieval folklore credited
them with prophecies foretelling
Christianity, making possible a
reconciliation between classical
and Christian thought. The oracle
of Delphi was famous throughout
the ancient world, its priestess
uttering her prophecies while
seated on a tripod over a fissure
through which seeped mysterious,
intoxicating and inspiring vapours.
Michelangelo's Delphic sibyl is a
beautiful, strangely distracted
creature, her headdress and the
band across her forehead
emphasizing her resemblance to
the artist's earlier Madonnas.

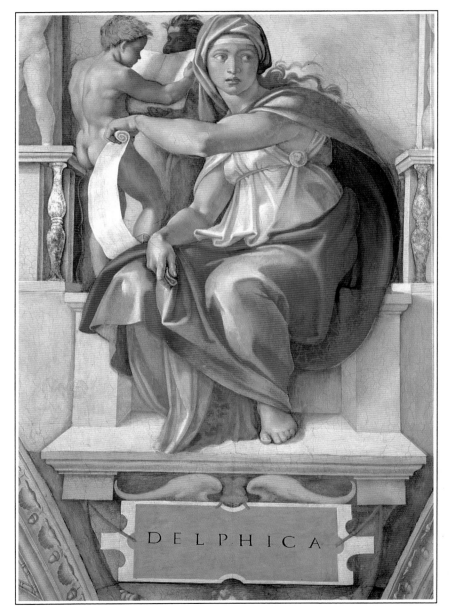

DELPHICA

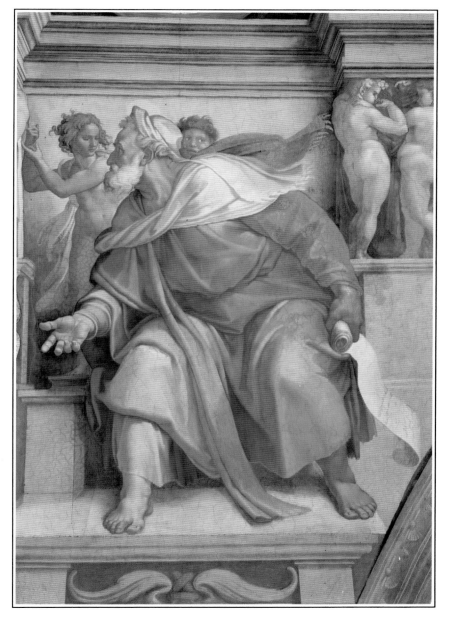

▷ **The Prophet Ezekiel**
Sistine Chapel 1508-12

Fresco

FIVE HEBREW PROPHETS and 5 sibyls alternate along the length of the Sistine ceiling, and there is also a prophet at each end, with the mighty figure of Jonah (page 36), symbolic of Christ, directly over the altar. However, the significance of the other prophetic figures is less clear. Ezekiel, enthroned below *The Creation of Eve*, was a prophet of doom, foretelling the destruction of Jerusalem and the Jewish nation, but he was also notable for his emphasis on the universality of God's dominion and the responsibility borne by the individual soul. Here he is shown as a forceful, dynamic figure. He leans forward, perhaps engaged in denunciation or debate, making the figures behind him and the painted 'sculptures' on either side look distinctly effete.

▷ **The Cumaean Sibyl**
Sistine Chapel 1508-12

Fresco

THE SIBYLLINE BOOKS were
revered by the ancient Romans,
who consulted them whenever
they had to make an important
decision. The books had been sold
to one of the early kings of Rome,
Tarquinius Superbus, by the sibyl
of Cumae in Southern Italy. She is
said to have offered the king nine
books; when he refused to pay her
price, she burned three and
offered the remaining six for the
same amount. When he
continued to refuse, she burned
another three. At which point
Tarquinius gave in! The
Cumaean sibyl on the Sistine
ceiling is a potent symbol of
ancient Rome, but she must also
have been included for supposedly
prophesying the coming of a
Redeemer who would be born to
a virgin. As with the biblical
scenes in the centre of the ceiling,
the prophets and sibyls became
larger, bolder figures in the course
of Michelangelo's labours; by
comparison with her Delphic
rival (page 32), the Cumaean sibyl
is a huge creature who looks
distinctly uncomfortable in her
narrow niche.

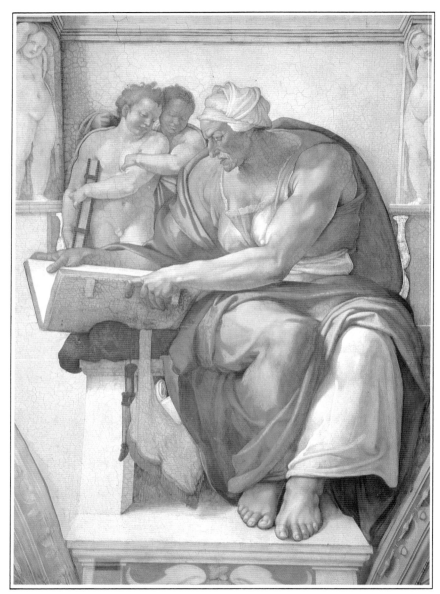

▷ **The Libyan Sibyl**
Sistine Chapel 1508-12

Fresco

PAINTED WHEN MICHELANGELO
was approaching the end of his 4
years of work on the ceiling, this
magnificent creature shows the
artist at his most daring and
inspired. The pose, with the
sibyl's body turning right round
to grasp the book, is a *tour de force*,
and the cleaning of the ceiling
(completed in 1989) has revealed
the loveliness of the original
colours. The figure is no longer
confined by the niche. Instead of
sitting on the throne, she is
poised, dancer-like, in front of it.
The effect is not spoiled by the
block which supports the sibyl's
left foot, even though
Michelangelo seems to be
pointing out the arbitrary nature
of its presence by making it trap a
piece of drapery. The significance
of the pose remains obscure, and
the sibyl can be interpreted as
either taking charge of the book
or putting it away from her,
perhaps abandoning her vocation
in submission to the Christ-figure
of Jonah.

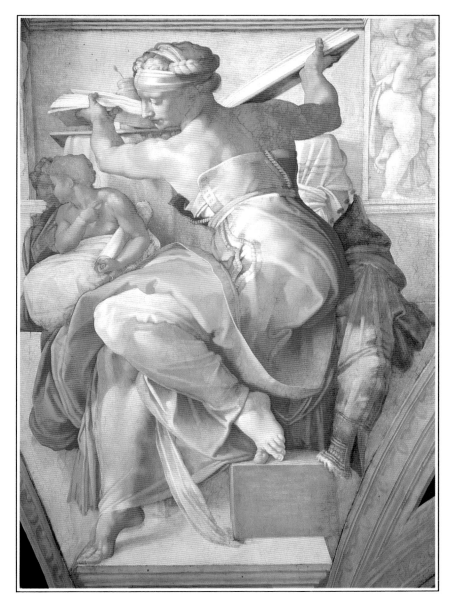

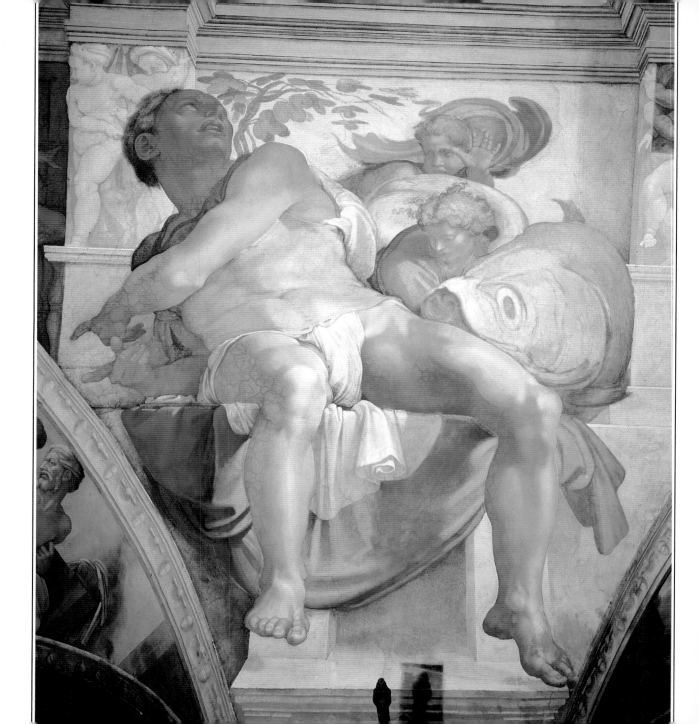

Detail

◁ **Jonah** Sistine Chapel 1508-12

Fresco

AT FIRST SIGHT, Jonah's size and prominence in Michelangelo's scheme are puzzling. The prophet sits enthroned at the far end, over the altar, his body thrown back in an intensely dramatic pose. The painting itself is a *tour de force*, since the surface is actually curving in the opposite direction, down from the ceiling to the wall. The key to Jonah's importance lies in the medieval and Renaissance belief that events in the New Testament were prefigured in the Old, so that each had a symbolic as well as a literal meaning. When Jonah tried to escape his destiny as a prophet, fleeing by sea, God sent a terrible storm which threatened to sink the ship. Jonah told the sailors to throw him overboard, being the cause of the trouble, and was swallowed by a great fish. He spent three days in its belly before being spewed up on shore. Jonah was consequently taken as foreshadowing Christ himself in his voluntary sacrifice, his entombment, and his 'resurrection'.

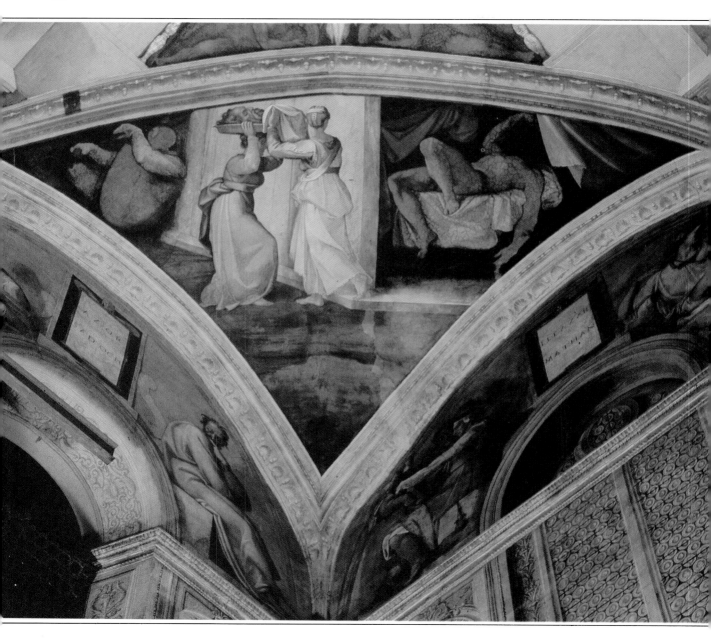

◁ Judith and Holofernes
Sistine Chapel 1508-12

Fresco

AMONG OTHER THINGS, Michelangelo's Sistine ceiling is a feat of illusionism, mingling real and false (that is, painted) elements. For example, the niches in which the prophets and sibyls sit are painted architecture, but the roughly triangular shapes along the sides of the ceiling are spandrels, real architectural elements linking the curving ceiling with the wall below. On each spandrel Michelangelo painted an imaginary portrait of an ancestor of Christ. The corners of the ceiling are occupied by double spandrels, which form a distinct series, showing the perils from which the Jews were delivered by God's will. Judith was a Jewish widow who saved her city from the Assyrians by plying the enemy commander, Holofernes, with strong drink. When he fell into a drunken stupor, she cut off his head. Here she is shown looking back at Holofernes' sprawling, decapitated body as she places a cloth on his head, which her maid is about to carry away.

Ignudi
Sistine Chapel 1508-12

Fresco

▷ *Overleaf pages 40-41*

MICHELANGELO'S PAINTINGS on the Sistine Chapel ceiling form a single great work of art, and should also be seen as a complex theological scheme in which all the parts interlock. The major exceptions to this statement seem to be the *ignudi* – the twenty naked youths or 'athletes' who fill the spaces left by the alternation of larger and smaller panels down the centre of the ceiling. Each pair of *ignudi* supports a bronze medallion carrying a biblical scene (here it is the death of King David's unruly son Absolom, hanged by his own hair). But this can hardly be the real reason for including creatures with such splendid physiques, pictured in an extraordinary variety of poses. The natural conclusion is that they are Michelangelo's tribute to the classical statuary that so influenced his art. Decoratively speaking, the *ignudi* break up the grid of painted architecture enclosing other scenes and figures, thereby energizing the entire surface.

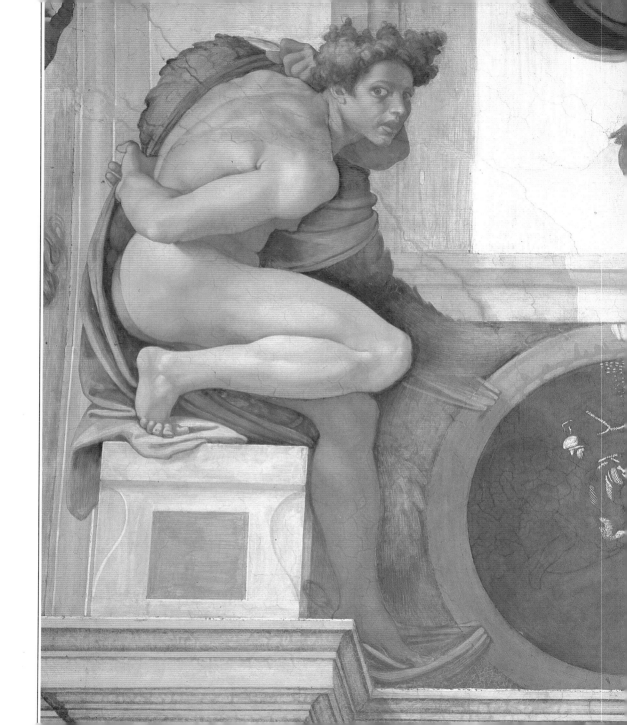

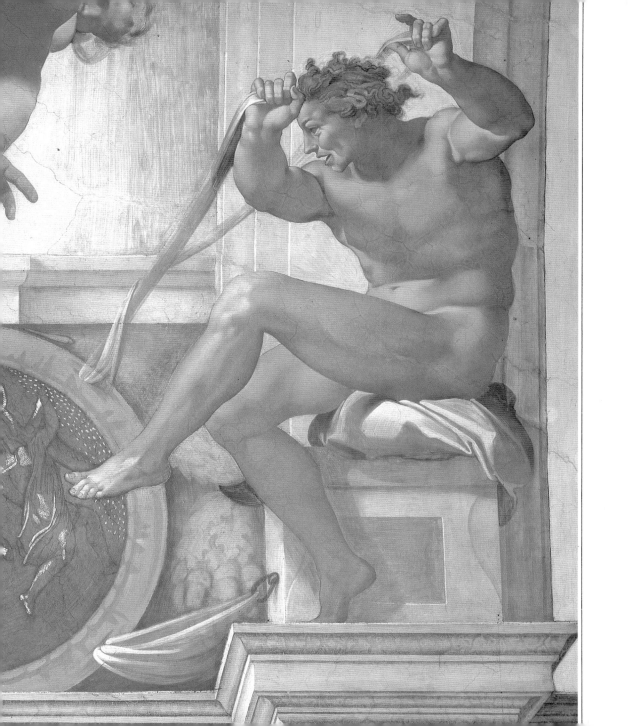

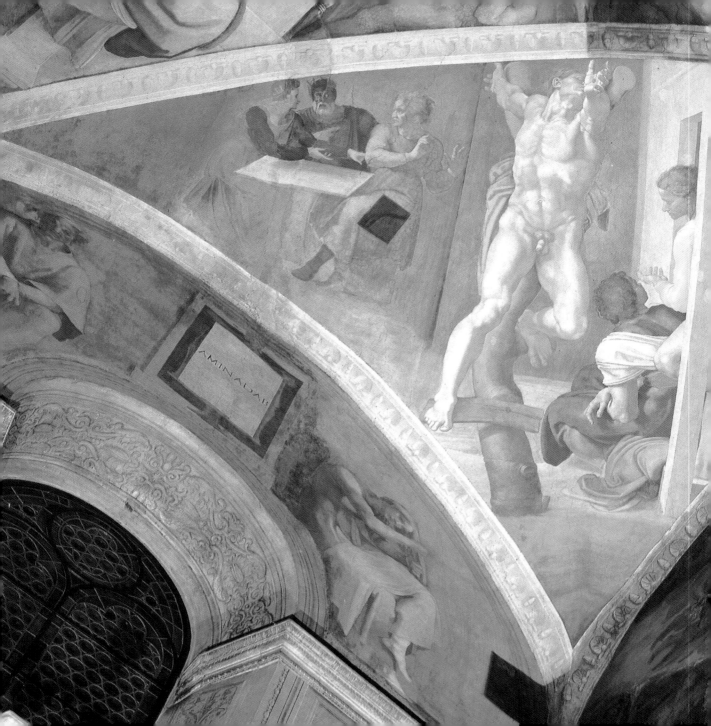

AMINADAB

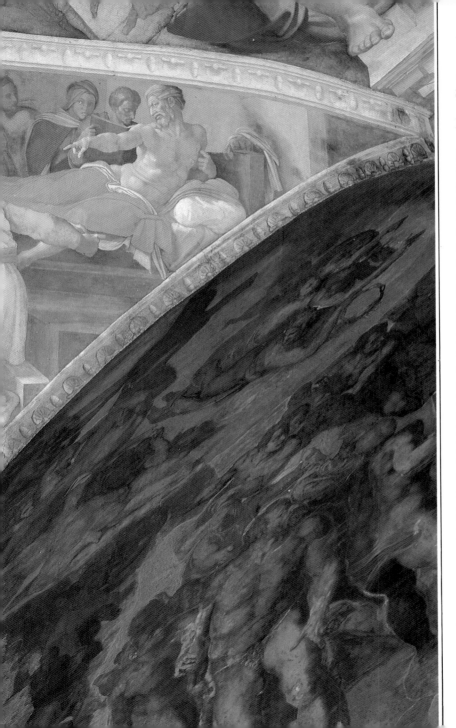

◁ **The Death of Haman**
Sistine Chapel 1508-12

Fresco

LIKE *JUDITH AND HOLOFERNES* (page 38), this picture was painted on the curved surface of a double spandrel, an architectural element installed at the point where the sloping ceiling meets the junction of two walls. Into this awkward space Michelangelo has crammed 4 different events from the story of Esther, creating a tumultuous scene that is confusing and yet intensely dramatic and moving. Esther was the biblical heroine who married the king of Persia and managed to prevent the execution of her foster-father, Mordecai, and the destruction of the king's Jewish subjects. At a banquet (left) in honour of Haman, the minister who planned these atrocities, Esther denounced the plot, and Haman was hanged on the gallows that he had prepared for Mordecai. Michelangelo decided to vary from the biblical account and show Haman being crucified, presumably as part of the system of references to Christ which culminate in the figure of Jonah (page 36).

▷ **Eleazar and Mathan**
Sistine Chapel 1508-12

Fresco

THE LAST GROUP OF ceiling
paintings done by Michelangelo
were the lunettes, horseshoe-
shaped areas below the spandrels
(page 38 and 43) which actually
ran along the tops of the walls;
each 'horseshoe' fitted neatly over
the arch of a window.
Michelangelo filled the spandrels
and lunettes with imaginary
portraits of the ancestors of Christ,
most of them mere names from a
genealogical list. Either for this
reason or because Michelangelo's
inspiration was flagging, they form
a curiously subdued series. *Eleazar
and Mathan*, though enlivened by
the hint of Renaissance display in
the costumes, is distinctly uneasy
in atmosphere. To the left, a child
is being dandled joylessly while a
wild, sinister face looks on; to the
right, a handsome young man
strikes a rather effete pose,
apparently indifferent to his
family. According to the Gospels,
Eleazar was the father of Mathan,
and Mathan was the grandfather
of Joseph, the husband of the
Virgin Mary.

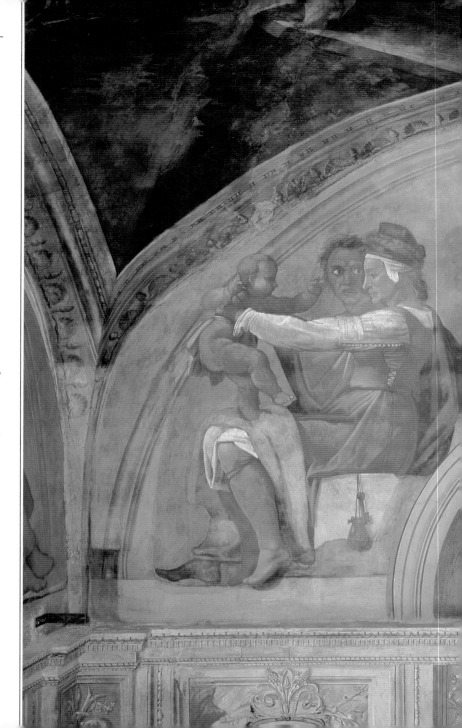

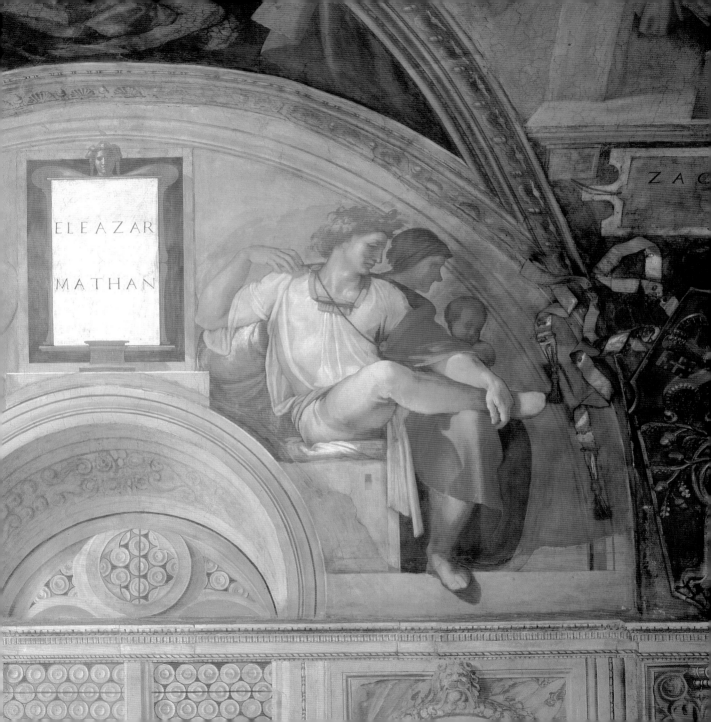

ELEAZAR

MATHAN

ZAC

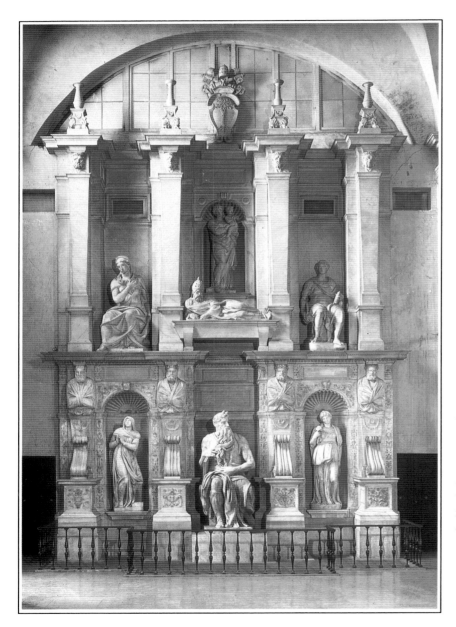

◁ **The Tomb of Pope Julius II**
1505-45

Marble

MICHELANGELO WAS CALLED to Rome in 1505 by Julius II, and given a 5-year contract to create an enormous free-standing tomb for the Pope. But having spent months assembling the marble required, Michelangelo found that the Pope had lost interest. A famous quarrel and reconciliation followed, after which Michelangelo painted the ceiling of the Sistine Chapel. After Julius' death the 40-year 'tragedy of the tomb' became increasingly convoluted, as the heirs and other would-be patrons competed for Michelangelo's services and new contracts progressively reduced the scale of the project. The fifth and final contract was signed in 1542, and a relatively modest wall tomb, shown here, was completed and set up in 1547 in the Roman church of San Pietro in Vincoli. Michelangelo's final contribution was little more than the great *Moses* (page 47) and the figures of Rachel and Leah on either side of it.

▷ **Moses** c1515

Marble

THIS WONDERFUL FIGURE is filled
with the fearful power, in Italian
terribilità, for which Michelangelo's
works were already famed in his
own lifetime. But although it
became the centrepiece of Julius
II's tomb (opposite), it was
originally intended to be one
among many figures, standing on
the first-floor corner of a huge
funerary monument. Moses is
seated, with the tables of the law
under his right arm, apparently
lost in thought; but he radiates
authority, and the tumblings of his
long tangled beard and deeply
carved draperies hint at his
immense reserves of energy. Not
surprisingly, *Moses* has been
interpreted as an idealized
portrait of Julius, or of
Michelangelo himself. The horns
on the figure's head are based
on a mistranslation of the Hebrew
word for a halo. By Michelangelo's
day the mistake had been
admitted, but the sculptor must
have liked the effect and decided
to retain it in defiance of
contemporary scholarship.

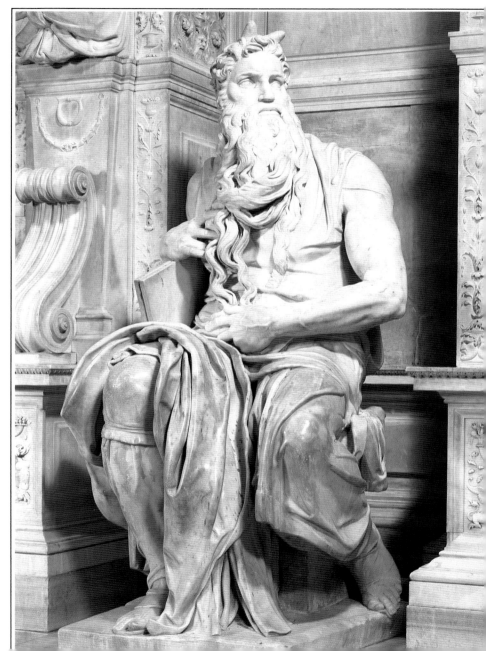

▷ **The Dying Slave** c1513

Marble

THIS IS ONE OF THE FIGURES carved by Michelangelo for the tomb of Julius II (page 46), although in the event it was not incorporated in the monument. In May 1513 Michelangelo signed a new contract with Julius' heirs, and for about 3 years he was able to work on the project with few interruptions; among his more or less finished works were *The Dying Slave*, *The Rebellious Slave* and *Moses* (page 47). The male body was Michelangelo's principal vehicle of expression, but he produced nothing quite like this languidly voluptuous creature, who may simply be stirring in a troubled sleep. Whether or not the figure represents a slave, the bands around his chest and wrist indicate constraint of some kind, and this is all the clearer because of the figure's pairing with a *Rebellious Slave*, who is struggling more actively with his bonds; such oppositions between active and passive are very common in Michelangelo's work.

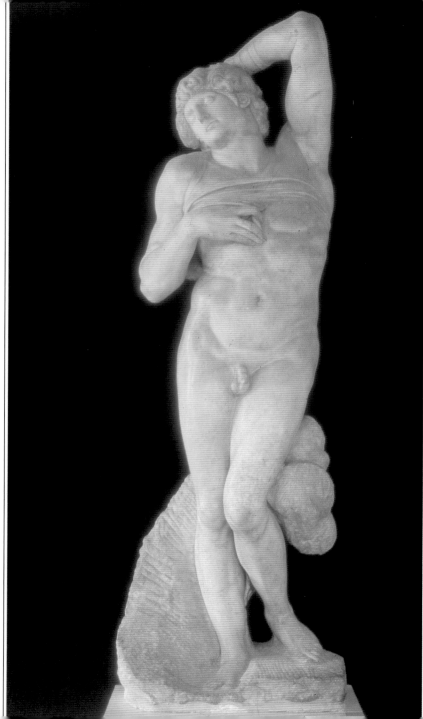

▷ **Victory** c1530-32

Marble

A LARGE FIGURE (well over life size), *Victory* was carved for the tomb of Julius II, at a time when Michelangelo's intermittent work on the project had already gone on for some 25 years. The somewhat bland expression on the face of *Victory*, along with his curious arm movement and turning posture, distract attention from the fact that he is humbling an enemy in the dust, his knee pressing down on the back of his elderly, bound captive. The curious impression made by this *Victory* may be partly explained by the fact that it was not designed to be viewed in isolation, but in company with many other figures on the tomb. The subject most probably alluded to the military exploits of the warrior-Pope Julius, but it has also been described as symbolizing the relationship between Michelangelo, now in his fifties, and a young man named Tommaso Cavalieri, to whom he became devoted after their meeting in 1532.

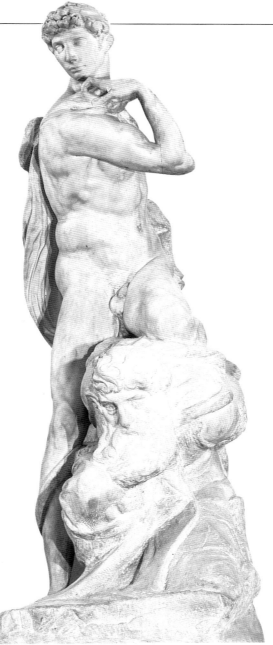

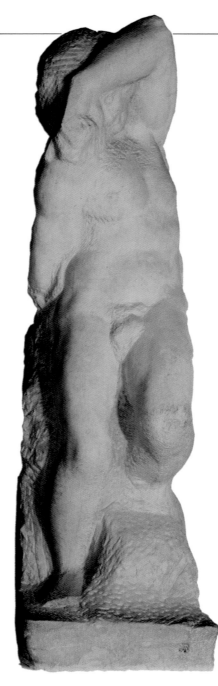

◁ **The Young Slave** c1532

Marble

THE HISTORY OF Michelangelo's tomb for Julius II (page 46) is littered with disputes, changes of plan and discarded statuary. Paradoxically, 4 incomplete figures have become as widely admired as many more obviously finished and polished works. They are variously known as 'slaves' or 'prisoners', perhaps because they appear to be trapped in the stone and struggling to free themselves. Even the date is uncertain, the conjectures ranging from 1519 to 1534, and, of course, it is perfectly possible that he worked on them intermittently over a period of years. *The Young Slave* is the most finished of the 4 and also the youngest-looking, bearing a certain resemblance to *The Dying Slave* (page 48). However, *The Young Slave* is a less sensual, more deeply sorrowful image, very much in sympathy with his fellow-slaves (pages 48-52).

▷ **Atlas** c1532

Marble

ATLAS AND THE OTHER unfinished 'slaves' (pages 48-52), intended for Julius II's tomb, are much taller than earlier figures for the same monument such as *The Dying Slave* (page 48). Since Michelangelo's concepts tended to grow larger and simpler over time, this suggests that *Atlas* and the others are relatively late, perhaps carved during the period after 1532, when Michelangelo agreed a new contract for the tomb with Julius' heirs. This would also explain the thicker, more burly figures, so different from the male ideal expressed in *David* (page 12) and *The Creation of Adam* (pages 28-29). An alternative explanation is that they are caryatids – figures designed to function as columns, bearing the weight of the structure above them. This is particularly clear in the case of *Atlas*, though, strangely, our knowledge of the fact does not make the apparent imprisonment of his head any the less thrilling and claustrophobic.

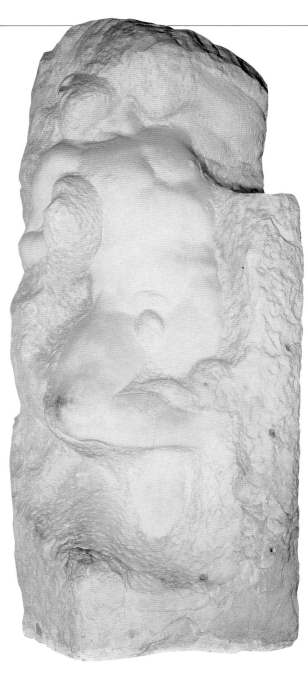

◁ **The Awakening Slave**
c1532

Marble

OF THE 4 UNFINISHED FIGURES (pages 48-52) made for Julius II's tomb, *The Awakening Slave* is the most poignant. The figure has hardly begun to emerge from the stone; it is waking but perhaps not yet struggling to be free. Michelangelo's technique – carving away the stone from the front of the block rather than attacking it from several angles – is particularly clear here. This approach fits in with his expressed feeling that he was not so much creating a sculpture as releasing an entity that already existed within the marble. What remains uncertain is whether or not he deliberately left works 'unfinished': in other words, whether or not the emotion evoked by a sculpture such as *The Awakening Slave* is an accident of time. Renaissance connoisseurs generally preferred completely finished works, but they were prepared to make an exception for Michelangelo. His biographer, Giorgio Vasari, valued these 'slaves' very highly precisely because they revealed the conception rather than the fulfilment of the works; so it seems perfectly possible that Michelangelo felt the same.

▷ **Lorenzo de' Medici** c1525

Marble

IN 1519 MICHELANGELO received another commission of epic proportions. The deaths of Giuliano de' Medici, Duke of Nemours (1516), and Lorenzo de' Medici, Duke of Urbino (1519), unexpectedly extinguished the main line of the powerful Medici family. The sole survivor, Pope Leo X, commissioned Michelangelo to commemorate them by building a funerary chapel on to the side of the family church, San Lorenzo in Florence, and furnishing it with suitably splendid tombs, carved by his own hand. Like so many of Michelangelo's undertakings, the tomb project ran into all sorts of problems, and when he left Florence for good in 1534, the tombs of the two dead dukes were more or less complete, but their more illustrious ancestors rested – and still rest – in a simple chest opposite the altar. Nevertheless the Medici Chapel is one of Michelangelo's grandest achievements. The figure representing Lorenzo is, despite the almost frivolous fantasy of his helmet, deeply impressive, his face in shadow as he seems to contemplate the riddles of life and death.

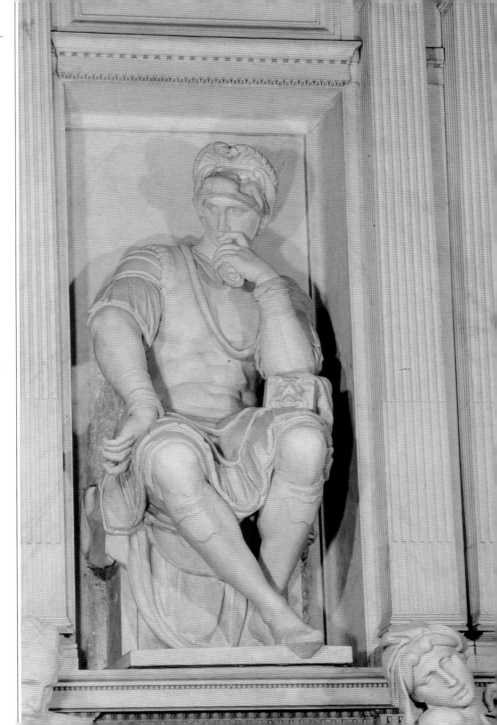

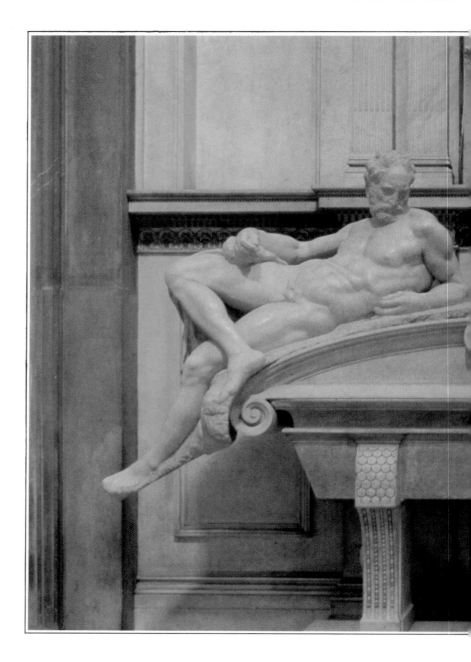

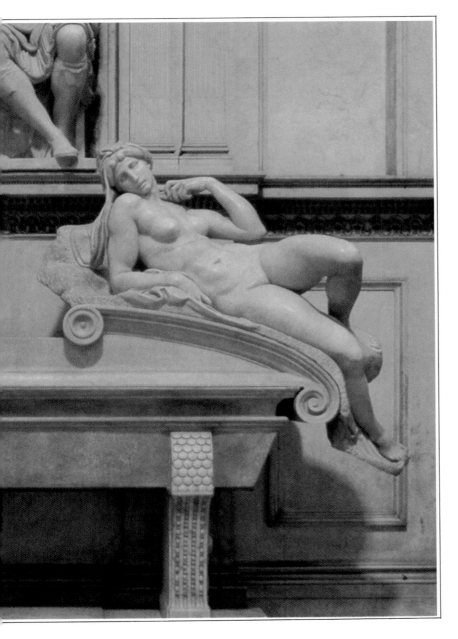

◁ **Dusk and Dawn** c1525

Marble

THE THOUGHTFUL FIGURE of
Lorenzo de' Medici (page 53)
occupies the central niche in the
imposing architectural framework
of his tomb. Directly below him
stands a sarcophagus which
supports the strangely languid
allegorical figures of *Dusk* and
Dawn. Their attitudes are very
much in keeping with the
reflective mood of the seated
Lorenzo; but no entirely
convincing explanation has been
advanced for the prevalence of
this twilight atmosphere in the
tomb. It is not simply the gravity
and stillness associated with
mourning and death, since the
nearly identical tomb of Giuliano
de' Medici, on the opposite wall
(page 57), breathes a very different
spirit. The figure of *Dusk* is more
highly finished than *Dawn*, whose
youth, powerful limbs and latent
sensuality make an ambiguous
impression, reflecting
Michelangelo's evident unease in
representing the female nude.

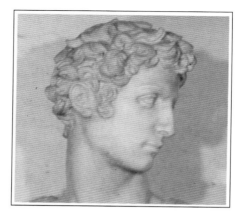

Detail

▷ **Giuliano de' Medici** c1532

Marble

GIULIANO'S TOMB is embedded in the wall of the Medici Chapel, opposite that of Lorenzo (page 53). The general scheme of the tombs is identical, but the mood of the carved figures is curiously different. Like Lorenzo, Giuliano wears a kind of Roman military fancy dress, but he is a much more alert figure, seated with a baton on his lap, his handsome head turned as though listening to a report by a subordinate on which he is about to take a decision. Contrasting figures such as Giuliano and Lorenzo – active and passive, striving and contemplative – are common in Michelangelo's work, but it is hard to believe that he would have arbitrarily imposed such a contrast on real people whom he was employed to commemorate. However, this is not impossible, since he high-handedly made the figures not true portraits but idealized types. When questioned about it, he retorted loftily, 'In a thousand years' time who will care what they looked like?'

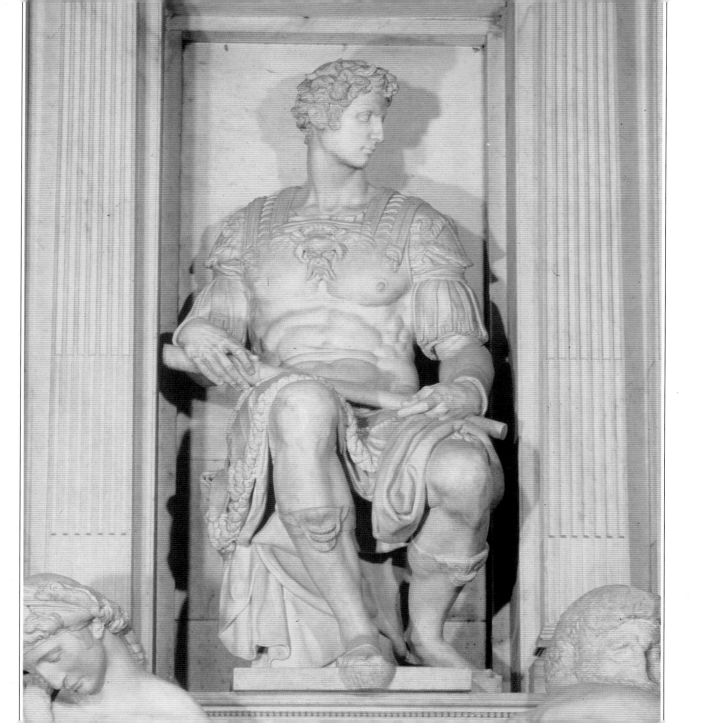

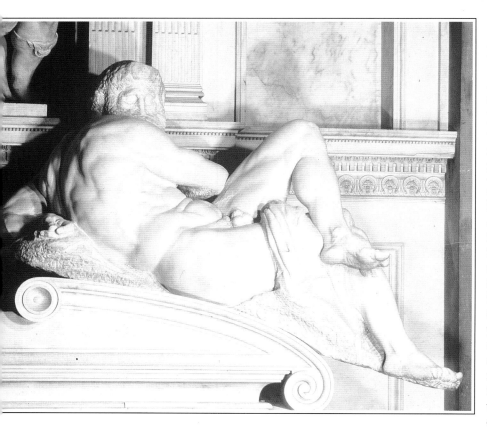

◁ **Day** c1532

Marble

DAY AND *NIGHT* (opposite) are sculpted allegorical beings from the tomb of Giuliano de' Medici. Like the corresponding figures of *Dusk* and *Dawn* (page 54-55) on Lorenzo de' Medici's tomb, they lie with their backs to each other on top of a sarcophagus, directly below the effigy of the dead man. *Day* is the most powerful of the four allegorical figures, with a thick, muscular torso. It almost certainly reflects his ambition to surpass admired Roman sculptures in this style, just as he had earlier surpassed the classical images of youthful male beauty. His characteristic employment of *contrapposto* – a twisting pose – reaches the height of virtuosity in this extraordinary conception, in which the head looks at the viewer over a turned-away shoulder, while the left leg is flung forward over the right. By contrast with the painstakingly detailed musculature of the torso, the head is only roughly blocked out, creating an impression of blind power.

▷ **Night** c1532

Marble

ONE OF MICHELANGELO'S best-known sculptures, *Night* is the pendant to *Day* (opposite) on the tomb of Giuliano de' Medici. Despite this thematic connection, *Night* has some exceptional features that distinguish it from all the other allegorical figures in the Medici Chapel. Mysteriously, *Night* is accompanied by several symbolic items associated with darkness and death: a crescent moon ornament in her hair, an owl, a sinister mask, and some poppies. Like many of Michelangelo's female nudes, she is not entirely convincing, yet her bent head, supported by her hand, and the complex turning pose are strangely memorable. Perhaps because they evoke powerful semi-conscious associations connected with birth and sex.

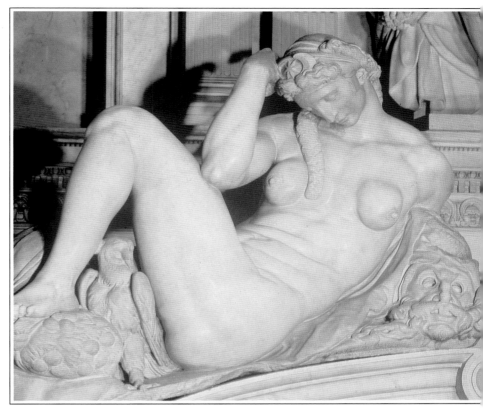

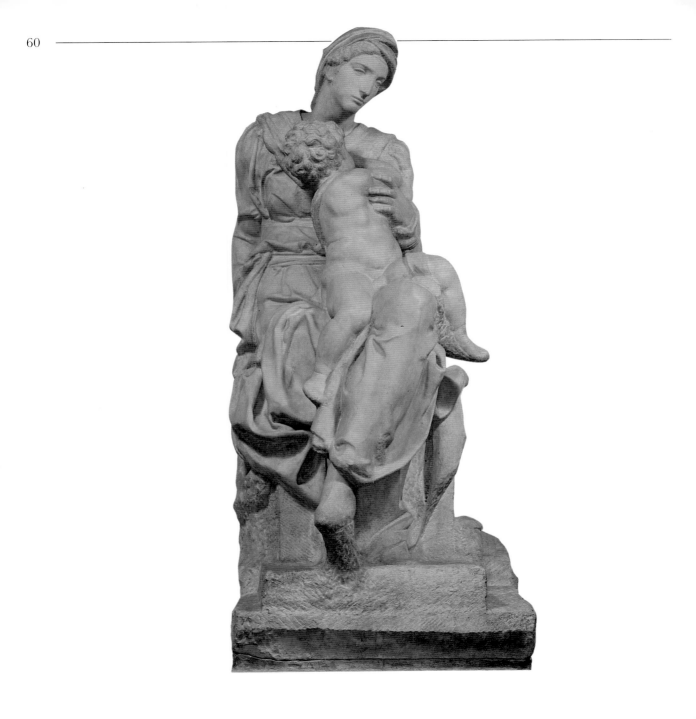

Detail

◁ **Madonna and Child** c1532

Marble

MICHELANGELO'S MEDICI
CHAPEL, in the Church of San
Lorenzo, Florence, contains the
tombs of the dukes Lorenzo and
Giuliano de' Medici (pages 53-
59). The effigies of the dead men
are positioned so that they are
gazing towards this *Madonna and
Child*. Like other works in the
Medici Chapel the *Madonna and
Child* is not easy to date; the
contours of the Madonna's face
(not fully finished, and covered
with a fine web of chisel marks)
suggest that she was carved at
about the same time as the *Victory*
(page 49) intended for the tomb
of Julius II. In this, his final
version of a Madonna and Child,
Michelangelo has further
accentuated the contrast between
the apprehensive mother and the
active but sheltering child, first
outlined some 40 years earlier in
The Madonna of the Steps (page 8).

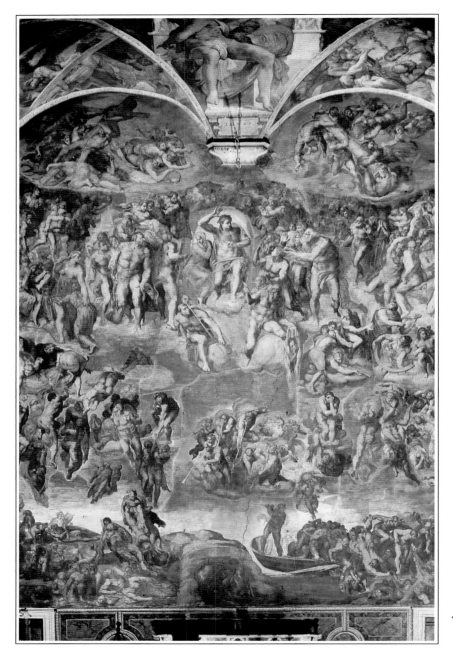

◁ **The Last Judgement**
1536-41

Fresco

IN 1534 MICHELANGELO settled in
Rome. A new Pope, Paul III,
commissioned a *Last Judgement* for
the altar wall of the Sistine Chapel,
whose ceiling Michelangelo had so
memorably painted over 20 years
before. The new work covered the
entire wall, even though this meant
destroying two of Michelangelo's
own earlier lunettes, as well as
paintings by other masters.
Strikingly different in mood and
style from the ceiling paintings,
The Last Judgement reflects the
increasingly sombre religious
outlook of the period and
Michelangelo's own spiritual
preoccupations. Below, on the left,
the dead leave their graves and
begin to take on flesh, summoned
by a group of angels blowing the
Last Trump. The centre of the
picture is dominated by Jesus and
Mary surrounded by apostles,
prophets and saints. Below, to the
right, the damned are being
dragged down and delivered to
Hell. When the fresco was unveiled,
the Pope is said to have fallen to
his knees in terror, begging
forgiveness for his sins. *The Last
Judgement* is shown here as it was
before cleaning, completed not long
before the publication of this book.

▷ **Christ, the Virgin and Saints** Detail from *The Last Judgement* 1536-41

Fresco

IN *THE LAST JUDGEMENT*, Christ is the embodiment of authority, his hand held up in a mighty gesture which has raised the dead and decided the destiny of all human souls. His mother shrinks away, averting her gaze from the damned: throughout the ages she has been the advocate of mercy, interceding on behalf of a sinful humanity; but now her work is done and there is no appeal against the sentences that have been passed. Michelangelo portrays Christ as a young, beardless hero, drawing on classical rather than traditional Christian imagery; but he is also brawny and thick-waisted, like so many figures in *The Last Judgement*, in distinct contrast to Michelangelo's earlier idealization of the male body. Each of the saints carries an object symbolizing his, or her, martyrdom. St Bartholomew, below Christ and Mary, holds out his flayed skin – on which, in a grim jest, Michelangelo has portrayed his own tormented features.

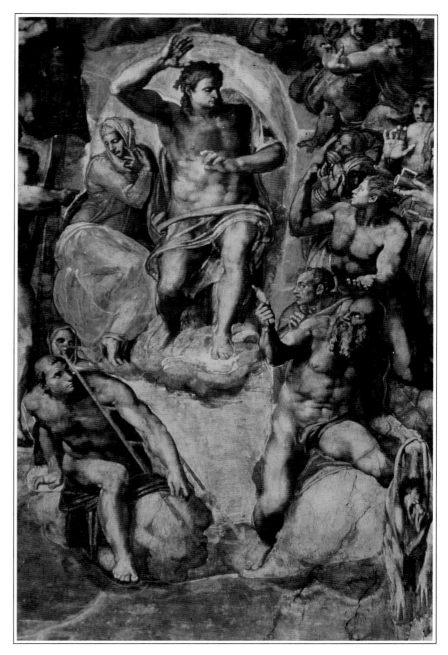

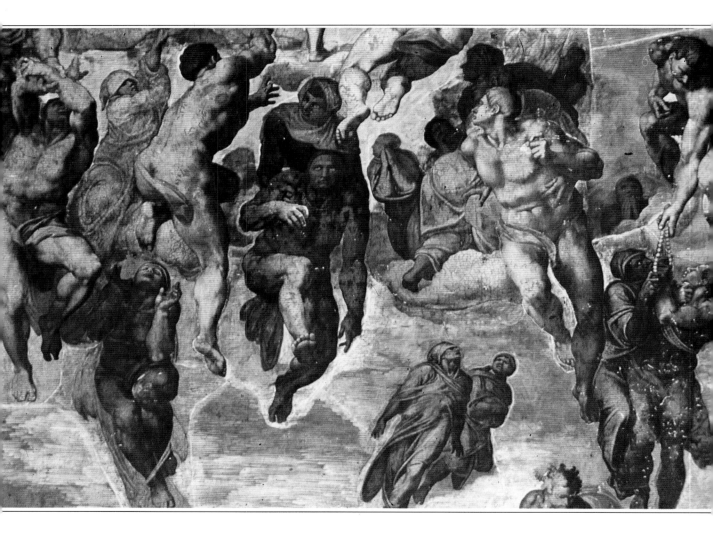

◁ **The Saved** Detail from *The Last Judgement* 1536-41

Fresco

THIS DETAIL IS TAKEN from the left-hand side of *The Last Judgement*, immediately above the awe-inspiring earthly scene in which the dead are awakening and quitting their graves. Here, the saved souls are ascending to heaven, experiencing varying degrees of difficulty as they do so: some rise unaided, but others have to be lifted or pulled up by powerfully muscled angels. One couple are being hoisted aloft at the end of a rosary, to which they cling fearfully. Evidently they are poor sinners, saved only because of their submission to the True Church, symbolized by the rosary which had been discarded by the Protestant foes of the faith.

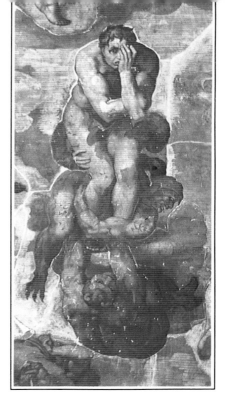

△ **A Damned Soul** Detail from *The Last Judgement* 1536-41

Fresco

THIS IS PROBABLY the most convincing, soul-shaking picture of despair in the history of art. The seated man has realized for the first time, and too late, just what it means to be damned; his pose, with arms crossed and hand over one eye, brilliantly conveys his state of mind. Unlike many of the other condemned sinners, he is too devastated to offer any resistance to the grinning demons who are pulling him down to the infernal regions. Typically, Michelangelo represents his demons, like his wingless angels, in the semblance of humans, although their claws give them away. Even allowing for the nature of the subject, Michelangelo's treatment of it has an intensity born of a new age in which the Catholic Church recovered its militancy and was counter-attacking against Protestantism.

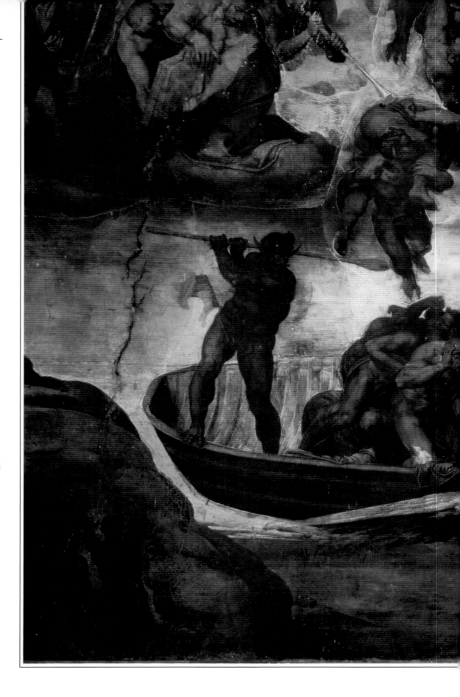

▷ **Charon ferrying the Damned** Detail from *The Last Judgement* 1536-41

Fresco

IN CLASSICAL MYTHOLOGY Charon was the ferryman who carried the shades of the dead across the River Styx to the underworld, where King Minos reigned. Here Charon's clients are the damned, and the underworld has become the Christian Hell, a place of eternal torment. Charon himself is shown as a kind of devil, gleefully driving the terrified souls out of his boat with blows from a paddle. Minos, his torso encircled by a serpent, waits on shore for his new subjects. This is actually one of Michelangelo's few portraits. While his work was in progress, a papal official named Biagio de Cesena complained that the nude figures were indecent, and Michelangelo retaliated by portraying him as Minos. When the unlucky Biagio complained to the Pope, Paul refused to do anything, wittily pointing out that Hell was one place over which he had no jurisdiction!

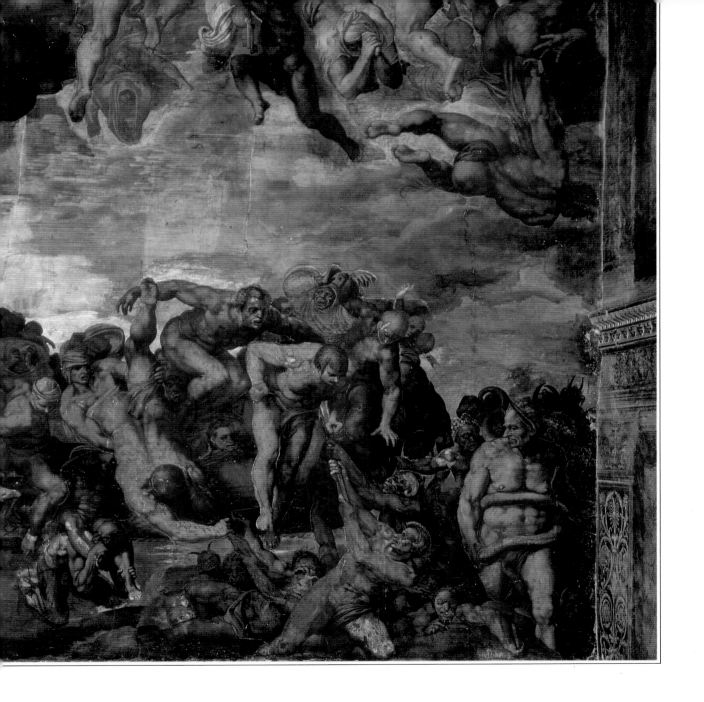

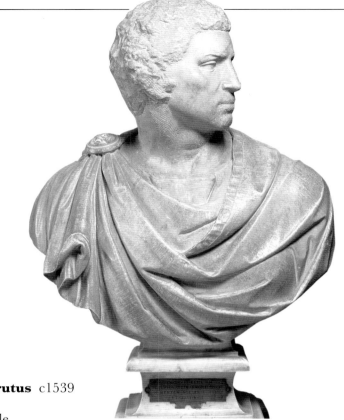

△ **Brutus** c1539

Marble

THIS IS AN ODDITY among Michelangelo's works: a bust, and carved as an imaginary portrait of an ancient Roman. Moreover it is an unmistakably political statement, since Brutus was the assassin of Julius Caesar and the subject clearly alludes to the recent murder of Alessandro de' Medici, the tyrannical ruler of Florence. In effect, Michelangelo was proclaiming his republicanism and praising Alessandro's assassin.

The bust is not completely finished (though the lifeless drapery was added by a pupil), and this fact was exploited by a later Medici Grand Duke who acquired the *Brutus*. He added an inscription to it, asserting that Michelangelo had abandoned it when he realized that he was glorifying murder. Nevertheless Brutus is a work of grave nobility, evidently modelled on Roman imperial busts.

▷ **The Conversion of St Paul**
1542-45

Fresco

NOT LONG AFTER FINISHING *The Last Judgement* (page 62), Michelangelo was given another commission by Pope Paul III: 2 frescoes for the Pope's own, newly built, private chapel, the Cappella Paolina (Pauline Chapel). *The Conversion of St Paul* represents a key moment in the history of Christianity, and its central figure is the Pope's namesake. Saul of Tarsus was a zealous persecutor of the early Christians until, on his way to Damascus, he was struck down and blinded by a great light and heard the voice of Jesus himself reproaching him. Saul eventually recovered from his blindness and, as the Apostle St Paul, became the driving force in bringing Christianity to the gentiles. Michelangelo makes visible Jesus and the heavenly host, creating a contrast between the groups on earth and in the sky. A blinding bolt sends Saul's companions reeling back; he himself lies stunned in the foreground while his horse bolts. Unusually, Michelangelo portrays Saul as an old man, presumably to identify him with Pope Paul.

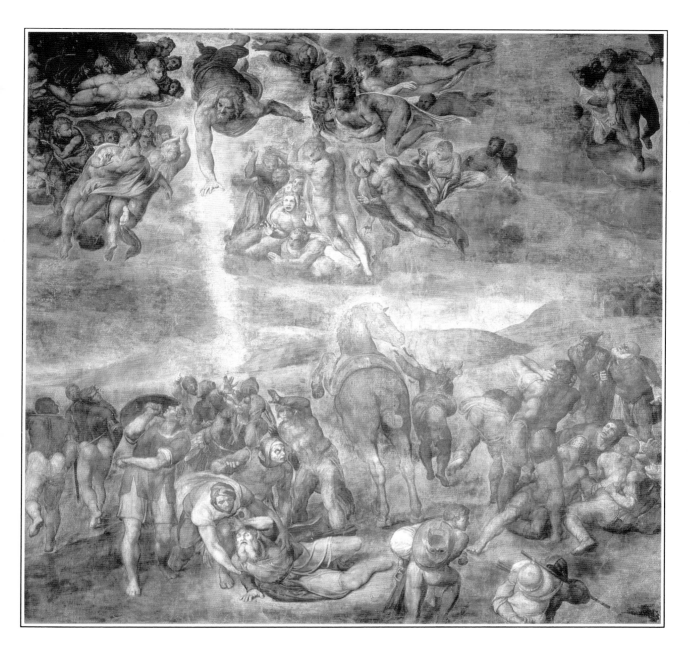

Detail

▷ **The Crucifixion of St Peter** 1546-50

Fresco

HAVING PAINTED THE conversion of the Pope's namesake, St Paul (page 69), Michelangelo completed his commission with this culminating scene from the life of St Peter. It was more common to picture Christ handing over to Peter 'the keys to the kingdom' (that is, the Kingdom of Heaven), on which papal authority was based, and the crucifixion may have been Michelangelo's own choice. According to tradition, Peter was crucified upside down at his own insistence, since he was unworthy to share the same fate as Jesus. Michelangelo has composed the scene so that, as the cross is being raised, Peter looks out at the viewer with grim deliberation. Despite a new softness in his colours, Michelangelo's late style seems like a rejection of the classical nobility in which he formerly delighted; instead, the heavy bodies and the fateful atmosphere create a quite different kind of sombre grandeur.

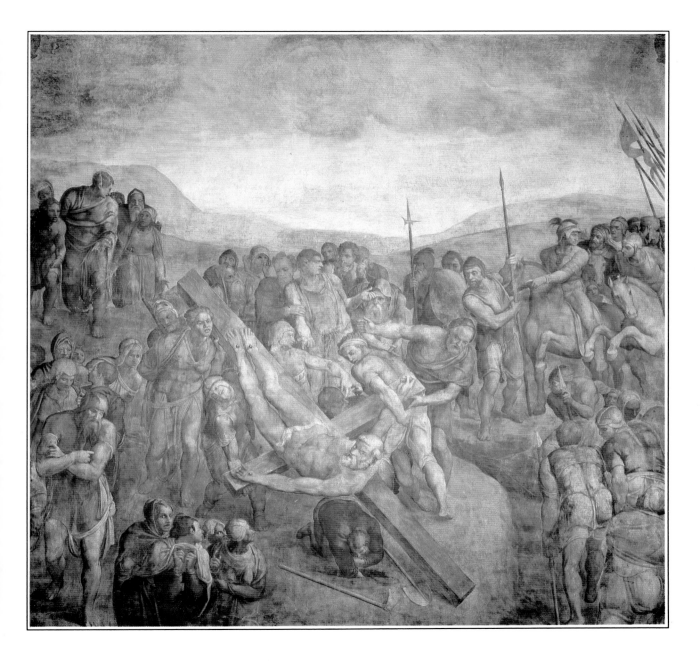

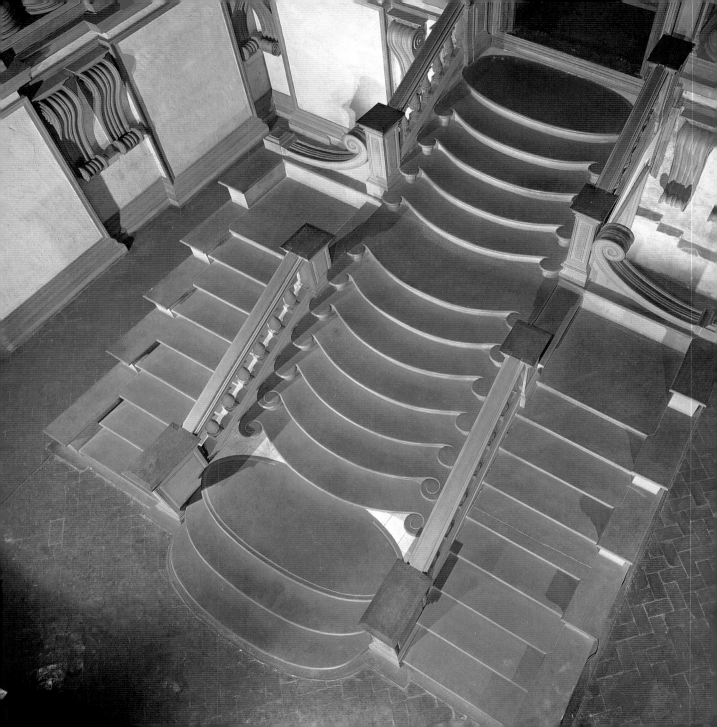

◁ **The Vestibule of the Laurentian Library, Church of San Lorenzo, Florence** c.1559

THE RENAISSANCE ARTIST was regarded as a creative man-of-all-work, so Michelangelo's involvement in architectural commissions was not unusual. In fact, these took up an increasing amount of his time, much of it devoted to this church of his powerful Medici patrons. Michelangelo effectively designed the Medici Chapel as well as its contents (pages 53-61); and between 1524 and 1534 the great Laurentian Library was built to his designs. The most celebrated part of the library, the staircase that almost completely fills the vestibule, was not built until 1559, when Michelangelo, long resident in Rome, was persuaded to send a model from which the work could be carried out. The result, a series of steps that seem to flow downwards like liquid lava, is one of his most extraordinary achievements.

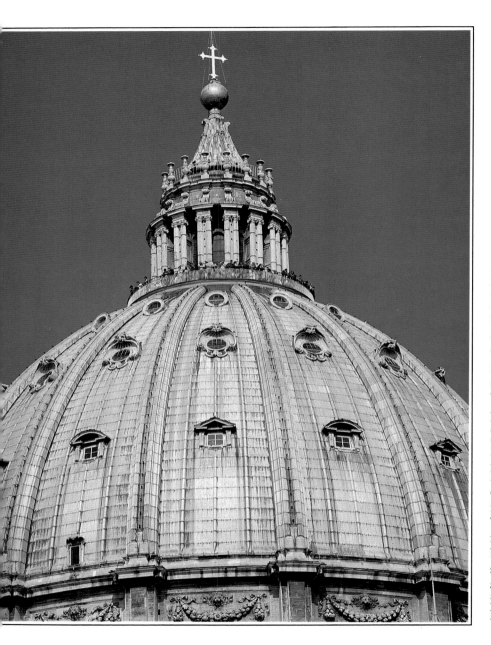

◁ ▷ **St Peter's, Rome**
1546-64

FOR THE LAST 17 years of his life
Michelangelo was the chief
architect of St Peter's, the church
begun 40 years earlier on the
orders of Pope Julius II. The site
was of immense symbolic
importance, since St Peter was
said to have been buried there.
The scale and ambition of the
project were such that generations
of architects worked on it, both
before and after the 71-year-old
Michelangelo took over. Though
limited by what had already been
done, Michelangelo simplified and
improved the plan for St Peter's.
The present great dome is a
modified version of his design, and
beneath it a mighty, sculptureque
section of the exterior, with
alternating wide and narrow bays,
is the most visibly personal of
his contributions.

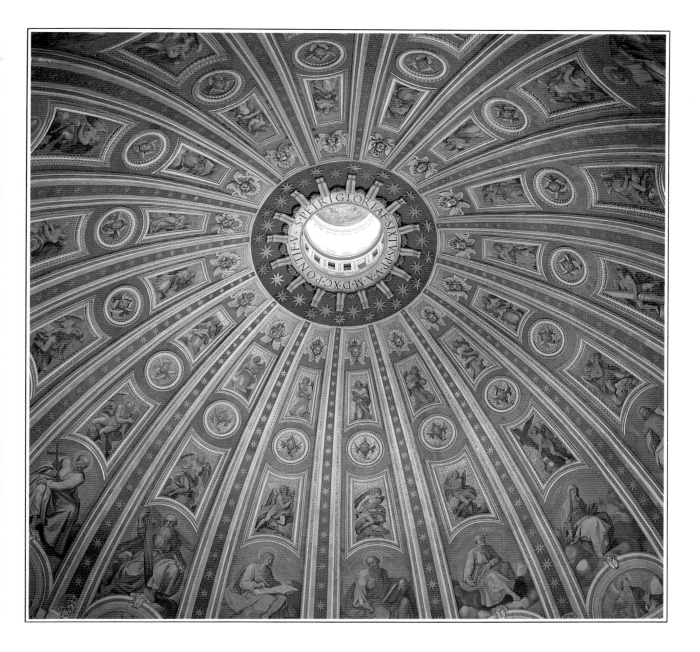

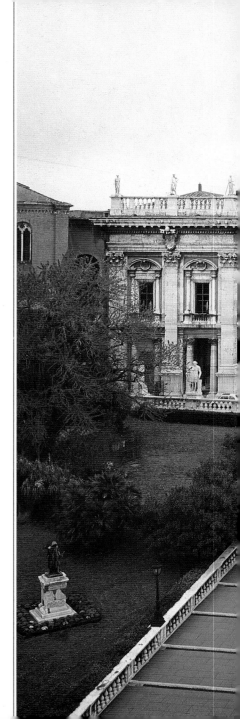

▷ The Piazza del Campidoglio, Rome

THE PIAZZA DEL CAMPIDOGLIO is Michelangelo's claim to fame as a town planner. The site is the former Capitoline Hill, the civic centre of ancient Rome. By the early 16th century it was run down and almost inaccessible, until Pope Paul III decided to restore it. In 1538 the ancient bronze equestrian statue of the Roman emperor Marcus Aurelius – the only surviving monument of its kind – was set up on the hill; Michelangelo designed its base, and at some point over the next few years worked out a set of plans involving ramps, buildings and a pavement carrying an oval geometric pattern, all integrated into a symmetrical scheme of a kind that had never been seen before. Though finished almost a century after his death, the piazza is essentially laid out according to Michelangelo's design, although Marcus Aurelius is now in a museum.

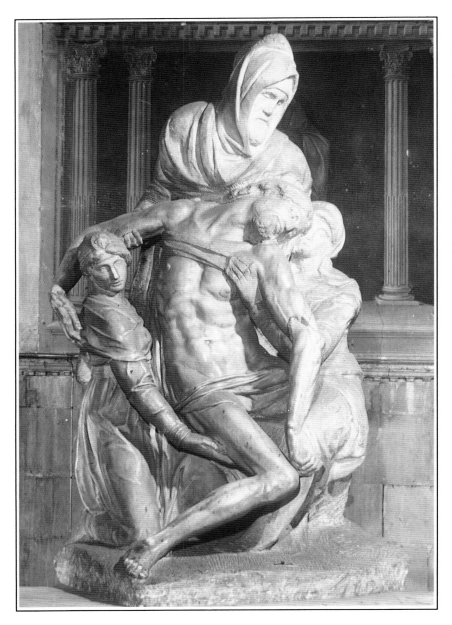

◁ **Pietà** c1550

Marble

EVEN IN HIS LAST YEARS
Michelangelo found time for
sculpture; often this meant working
late at night, by the light of a
candle stuck in his hat. This group
is generally labelled a *pietà* (Mary
mourning the dead Christ), but is
actually more like a deposition
(taking the body down from the
cross) or even an entombment. The
tall, hooded figure represents
Nicodemus, who is said to have
carried Christ's body to the tomb;
the others are Mary Magdalene
and the Virgin Mary. Michelangelo
is believed to have given
Nicodemus his own features,
carving the group for the altar of
the church in which he intended to
be buried. But, becoming
dissatisfied with the work, he
smashed it up. His assistant
Calcagni later put it back together
rather crudely (Christ's left arm is
patched and his left leg is missing)
and finished the Magdalene in his
bland style; yet the poignancy of
Michelangelo's original concept
remains undiminished.

ACKNOWLEDGEMENTS

The publisher would like to thank the following for their kind permission to reproduce the paintings in this book:

Bridgeman Art Library, London/Casa Buonarroti, Florence: 8; /**Casa Buonnarroti, Florence**: 9; /**St Peter's, Vatican**: 11; /**Galleria dell'Accademia, Florence**: 12, 13; /**Galleria degli Uffizi, Florence**: 14-15; /**Royal Academy of Art, London**: 16-17; /**Bargello, Florence**: 18; /**Galleria dell'Accademia, Florence**: 19; /**San Pietro in Vincoli, Rome**: 46; /**Louvre, Paris**: 48; /**Palazzo Vecchio, Florence**: 49; /**Galleria dell'Accademia, Florence**: 50, 51, 52; /**Cappella Medici, Florence**: 53, 54-55, 57, 58, 59; /**Vatican Museums & Galleries, Rome**: 62, 63, 64, 65, 66-67; /**Cappella Paolina, Vatican, Rome**: 69, 70-71; /**Museo dell'Opera del Duomo, Florence/Index**: 78

Robert Harding Picture Library, London: 74, 75

© **Nippon Television Network Corporation, Tokyo, 1995**: 20-21, 22-23, 24-25, 26-27, 28-29, Cover, Half-title, 30-31, 32, 33, 34, 35, 36-37, 38, 40-41, 42-43, 44-45

Scala, Florence/Bargello, Florence: 10; /**S. Pietro in Vincoli, Rome**: 47; /**Cappella Medici, Florence**: 60; /**Bargello, Florence**: 68; /**Biblioteca Laurenziana, Florence**: 72-73, 76-77

Every effort has been made to trace the copyright holders and we apologise in advance for any unintentional omissions. We would be pleased to insert the appropriate acknowledgement in any subsequent edition of this publication.